IMAGES
of America

EPHRAIM

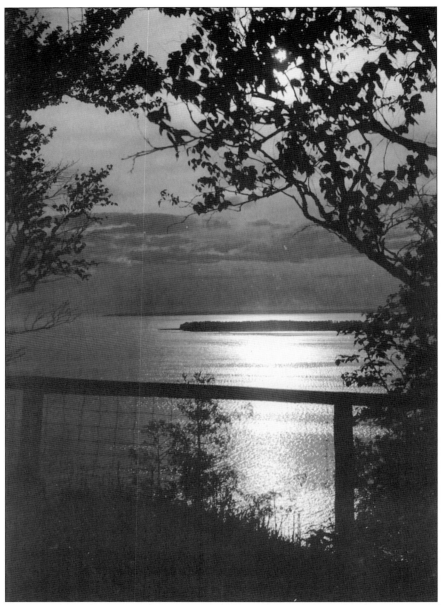

Shown is a vista from the Peninsula State Park bluff with Horseshoe Island in the moonlight as the focal point. Eagle Island, as it was known then, was where the settlement of Ephraim began in 1853 and where a number of those hoping to become part of the new community died in an epidemic—typical of the harsh reality that continually collided with the beauty surrounding it.

On the cover: Bowler hats and ties for the men and flowered hats and ruffled blouses for the ladies set the stage for an afternoon on the water. However, with the boat still tethered to the dock and no sails yet in evidence, it may be quite a while before this boatload of recreational sailors actually puts out to sea. (Courtesy of Ephraim Historical Foundation.)

IMAGES
of America

EPHRAIM

Ephraim Historical Foundation

ARCADIA
PUBLISHING

Copyright © 2008 by Ephraim Historical Foundation
ISBN 978-0-7385-5196-8

Published by Arcadia Publishing
Charleston SC, Chicago IL, Portsmouth NH, San Francisco CA

Printed in the United States of America

Library of Congress Catalog Card Number: 2007939869

For all general information contact Arcadia Publishing at:
Telephone 843-853-2070
Fax 843-853-0044
E-mail sales@arcadiapublishing.com
For customer service and orders:
Toll-Free 1-888-313-2665

Visit us on the Internet at www.arcadiapublishing.com

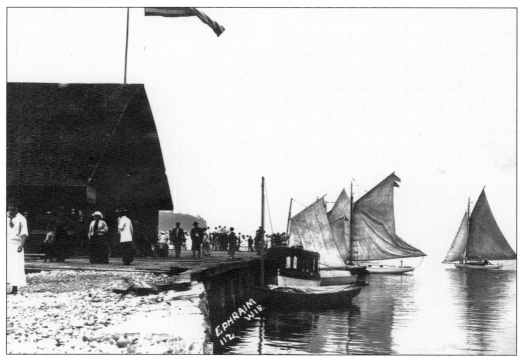

An array of small sail and power boats is gathered at the Anderson Dock, probably to take part
in the annual Ephraim Yacht Club Regatta. Dozens of boats and hundreds of people attend the
regatta every year on the first Saturday in August, both as participants and spectators.

CONTENTS

ACKNOWLEDGMENTS

Since the establishment of the Ephraim Foundation in 1949, hundreds of volunteers have worked thousands of hours to preserve Ephraim's historic character, properties, and artifacts. Without their love of the village and its history, Ephraim's unique qualities would not have endured. Equally important are those who donated the many photographs that have become part of the foundation's collections. Unless otherwise noted, images appearing in this book came from the Ephraim Historical Foundation's archives.

A number of people paved the way for this book through their research and writing. They include the foundation's business and marketing director Melissa Ripp, as well as foundation members Stanford Sholem and Linda Carey. Books and articles written in the past by Arthur Byfield, Carol Hardin, Hjalmar R. Holand, Malcolm D. Vail, and Charles Wiley were important sources of information about Ephraim's history. The foundation's publications committee, including Prilla Beadell, Bob and Nancy Davis, George Harmon, JoAnne Rankin, and Fred Schwartz provided valuable input. Thanks go to Frances and Paul Burton for their willingness to share their expertise with photographs, research, and writing.

This project, as well as many others, would never have been accomplished without the pivotal and devoted individuals who over the years have contributed their time, talents, and funds to the Ephraim Historical Foundation. They have helped accomplish its missions of preservation and education.

We acknowledge those hardy pioneers who braved the frontier in the earliest days, as well as those who came after. Theirs is a compelling story of the chronicle of Ephraim's transformation from a primitive settlement into a modern village. The choice of which photographs to use to tell the story was difficult, but within our limited space we have tried to weave the threads of history in a manner that honors all those who helped make Ephraim what it is today.

Finally, thanks go to Sally Jacobson, executive director and curator of the Ephraim Historical Foundation, who undertook the monumental task of compiling the book and writing much of it.

INTRODUCTION

Ephraim is a three-and-a-half mile square village of about 2,400 acres located on the Door County peninsula in the northeastern corner of the state. The community occupies the shoreline, hillside, and upland of a crescent-shaped bay known as Eagle Harbor. The bluffs of Eagle Harbor form a picturesque setting for this small village—so scenic that it has been the focus of many paintings and photographs.

The first visitors to Ephraim may have been Paleo-Indians, a rugged group of people who arrived near the end of the Pleistocene geologic period, 8,000 to 11,000 years ago. The Potawatomi, Menominee, and Winnebago Native Americans followed, and noting the abundance of fish and game, set up semi-permanent villages along the shores of the Door County peninsula, as well as on Washington and Rock Islands.

The village of Ephraim was settled in 1853 by Rev. Andreas Iverson and a small group of Norwegian Moravians. A Norwegian immigrant, Iverson wished to establish a settlement where the members of his flock could obtain their own land and worship in peace. After being ordained in Norway, Iverson received his charge from the Home Missionary Society in Bethlehem, Pennsylvania, to spread the gospel among Scandinavian immigrants in the newly formed state of Wisconsin. He arrived in Milwaukee in 1849, and subsequently moved his congregation to Green Bay. After hearing about a plot of land in the northern area of the Door County peninsula, he investigated it. Captivated by the area's potential, Iverson decided to settle his congregation there. Using borrowed money, he purchased more than 400 acres from the U.S. government. The congregation voted to call itself Ephraim, a biblical name meaning "doubly fruitful" and set about constructing homes and a church—the Ephraim Moravian Church, which was dedicated in 1859.

The early years of settlement were hard on Ephraim's small colony because the settlers had very few material possessions, and crops were difficult to cultivate. Wagon roads to other points on the peninsula were poor and often impassable, meaning most of Ephraim's contact with the outside world was through waterways. The first years of hard living eased in 1855 when Iverson successfully negotiated a contract for cedar posts with a Chicago telegraph company. Three years later, Iverson and the settlers agreed to sell 166 acres of their original purchase to Aslag and Halvor Anderson, provided the brothers would build a freshwater dock for the community, enabling sailing vessels to dock in Ephraim. The village quickly became a standard port of call for passing schooners and steamships. After the dock was built, Aslag built a general store at the gateway to the pier.

Iverson also arranged for the construction of the first school in northern Door County, a log cabin built in 1869. A larger, frame schoolhouse (the "Pioneer Schoolhouse") was constructed

11 years later to accommodate a growing student population. Lumbering, farming, and commercial fishing were important to the village economy at this time. Except for the construction of the two schoolhouses and the Bethany Lutheran Church and its parsonage, Ephraim remained surprisingly unchanged for the next several decades.

In 1887, Professor Charles Moss, a Greek instructor from the Normal School at Bloomington, and his family boarded a Goodrich steamer in Chicago, hoping to find a place where they could escape the summer swelter of central Illinois. When the steamer entered Eagle Harbor, Moss thought he might have found his place. At the Anderson Dock, he asked Adolph Anderson (son of Aslag) if there might be a place he and his family of five could stay for the summer. Anderson told Moss that Everena Valentine might consider taking boarders at her farmhouse by the Ephraim Moravian Church. Moss' family proceeded to the Valentine farmstead, where they received wonderful hospitality and food. Moss quickly told others of his good fortune in Ephraim, and soon a steady stream of visitors followed to enjoy the respite the village provided.

Tourism in Ephraim began in earnest with the construction of several large hotels: Valentine's Stonewall Cottage (which later became the Anderson Hotel), the Knudson House, Thorp's Eagle Inn, O. M. Olson's Hillside Hotel, Alfred Olson's Pine Grove, the Edgewater Resort, Evergreen Beach Hotel, and Hotel Ephraim. Many of these are still in use as lodging establishments.

Many people who came to Ephraim as tourists began to look at the village as an ideal place for their summer homes. Quite a few of these vacationers built cottages and soon formed a summer community. After the years of struggle and difficult living conditions, Ephraim gradually developed a thriving tourism industry as its economic base.

With the tourism industry comfortably established in Ephraim, the village began to grow in other ways. Norwegian and Moravian influences provided much of the background for Ephraim culture, as music in particular has always had deep roots in Moravian life. The Moravians, with their tradition of instrumental ensembles in the church, played a significant part in the development of the nationally known Peninsula Music Festival, which presented its inaugural concert in August 1953 under the direction of Dr. Thor Johnson. Johnson, who had lived in Moravian parsonages as a boy, conducted many Moravian music festivals and was a member of the Ephraim Moravian Church until his death in 1975. The village hall became a venue for theatre and musical productions, with local organizations using the hall to stage performances. Today the hall is the location of the very popular Ephraim Sunday Sing-Alongs, held during the summer.

Over the years, many artists have made Ephraim their home, appreciating the village for its wonderful mix of scenery and commercial enterprise. Galleries and studios abound in Ephraim, and the painters, potters, sculptors, weavers, woodworkers, and other craftspeople who have made Ephraim either a year-round or seasonal home have brought character and energy into the village.

No matter what hardships and successes the village of Ephraim has faced in the years since its settlement, a love for this tiny village and its beauty, as well as a commitment to preserve the values and history of Ephraim for future generations, bind the community together and keep the village in touch with its past.

One

TOPOGRAPHY AND TRAVEL

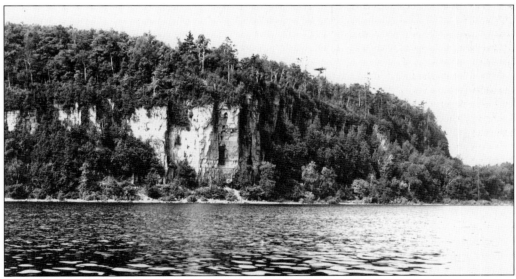

Eagle Bluff, at the south end of Peninsula State Park, is part of the Niagara escarpment that runs south to Chicago and east to New York State, creating the famous cliff over which Niagara Falls pours. The escarpment is made up of dolomitic limestone formed on the floor of an Ordovician-Silurian sea by sediment and the calcareous shells of tiny sea creatures. Atop Eagle Bluff is a lookout tower (1932) that affords a stunning vista of Ephraim and the islands in the bay.

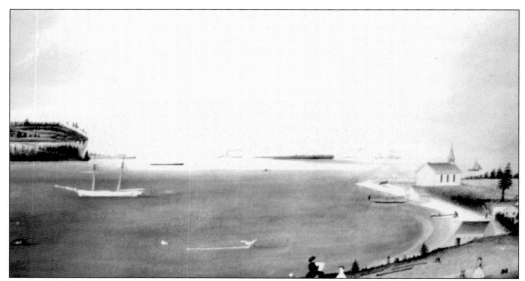

Ephraim was the first village established in Door County. Four Norwegian Moravian families traveled from Green Bay in May 1853 to the land curving northeast from Eagle Bluff (at left). In 1859, they built their church on the shoreline, as shown in this painting by their leader, Rev. Andreas Iverson. (Courtesy of Ephraim Moravian Church.)

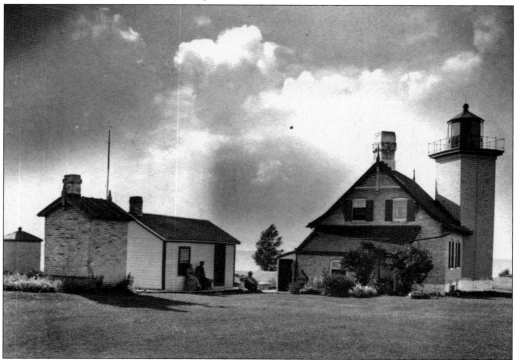

Built in 1868 for $12,000, Eagle Lighthouse was vital to protect ships in Green Bay and used a Fresnel lens from Paris that had a 16-mile range. Henry Stanley was the first keeper until 1883. He was succeeded by William Duclon, who operated the light until 1918. It became automatic in 1926 and opened as a museum in Peninsula State Park in 1963.

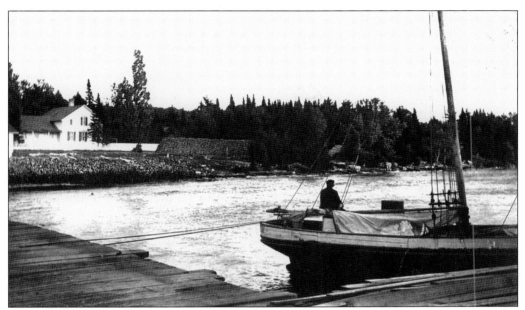

Ephraim's survival depended on getting tradable commodities, namely salted fish and rough lumber, to markets in Green Bay, Chicago, and Milwaukee. Schooners, called "lumber hookers," lined up at Ephraim docks and various other spots along the northern Door County shore to take on lumber. A sawmill was established to process the timber that came down the steep Ephraim hill on oxcarts or sleds, depending upon the season.

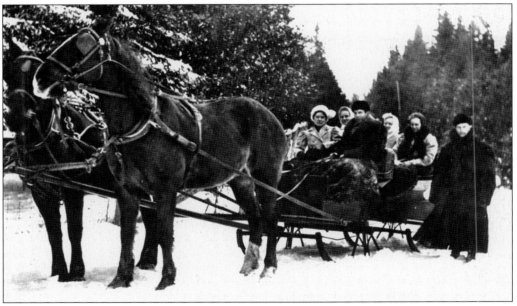

Ephraim was virtually isolated during its first 40 years. Men sometimes walked 75 miles to Green Bay for flour and salt. Almost all travel in early Door County was either by water or over rough trails through the woods. Wagons used during temperate weather were replaced by sleighs and sleds when snow arrived. Here the Anderson siblings take a winter ride under horsehair blankets, with Frank at the reins.

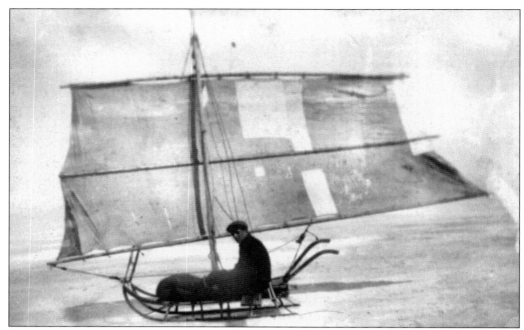

Sail sleighs were important for both small commerce and for recreation. In particular, goods were transported across the ice 20 miles to Marinette on a regular basis during the winter. Depending on the smoothness of the ice and the speed of the wind, the sleighs made fast time. Here a small sleigh with patched sails is ready to take off on the bay.

Ephraim's settlers initially supported themselves by subsistence farming, fishing, and selling logs. Farming posed the obstacles of thin topsoil over limestone as well as boulders deposited by glaciers. "Stone boats" pulled by horses allowed farmers to remove rocks from their fields and deposit them as stone fences (left). The cows are grazing peacefully on a rutted stretch of what is now Highway 42 between Ephraim and Sister Bay.

Ephraim's "upper road," now known as Moravia Street, while not subject to the flooding and swampy low spots of the main road, was typical of back roads throughout northern Door County—rutted, narrow, and uneven. Looking south toward the Lutheran and Moravian churches, the results of the usual rain runoff from the bluff can be seen as deep muddy furrows in the road.

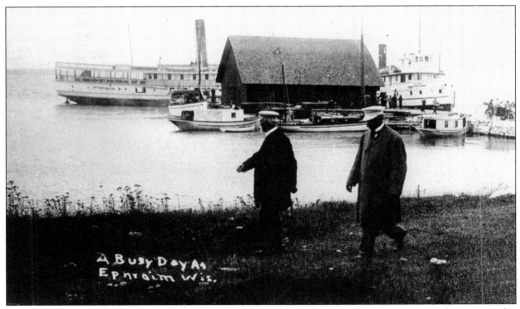

Emerging in Door County alongside agriculture was the tourism industry. In Ephraim in the late 18th century, "boat day" was a key event in the week. A crowd gathered at Anderson Dock before noon on Tuesday to greet the *Carolina* (docked here), a Goodrich passenger steamer that made regular stops along the Lake Michigan shoreline, delivering fresh vacationers from the south. Joseph Lindem (left) and friend are in the foreground.

A captain of a steamship calling at Ephraim in the early years was a character worthy of storybooks; he had to be rugged, smart, self-contained, and tough with crewmen but amiable with passengers. An archetype was Capt. Daniel McGarity (left), master of the steamship *Carolina.* Although much of the water traffic depended on exports of wood products, a tourism industry developed in the late 1890s after the Sturgeon Bay ship canal was completed. People from the cities to the south came on the *Carolina* to stay at the spacious hotels that sprouted along Ephraim's waterfront. Some of them arrived with trunks of clothes and even servants. They consumed huge meals and adjourned afterwards to the hotels' wide porches, where they watched the spectacular sunsets over Eagle Harbor.

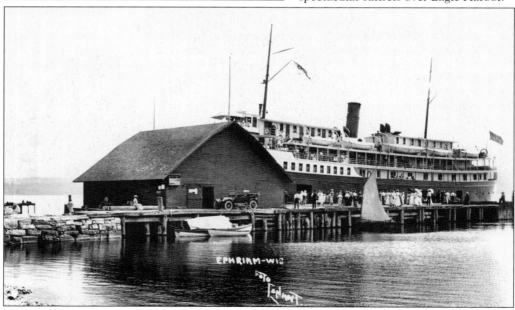

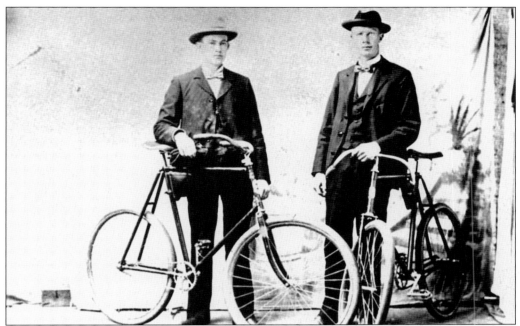

As time passed, travel evolved in various directions. Toward the end of the century, rail lines reached Menominee, Michigan, where steamers could ferry passengers across Green Bay to towns on the Door Peninsula. The Green Bay Ahnapee and Western Railroad built a line north from the city of Green Bay to Sturgeon Bay. Bicycles came into mode, more for recreation than transportation; however, historian Hjalmar R. Holand made his first trip to Door County by bicycle in 1898. Herman Hogenson and a friend are shown posing with their bicycles in a formal photograph. Below Frank Anderson holds one of his dogs on the back of an early Harley Davidson motorcycle, while another pet is eager to jump on for a ride (the name of the driver is unknown).

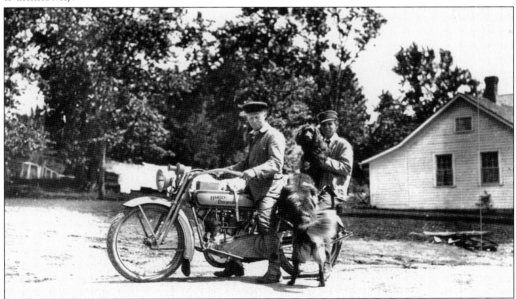

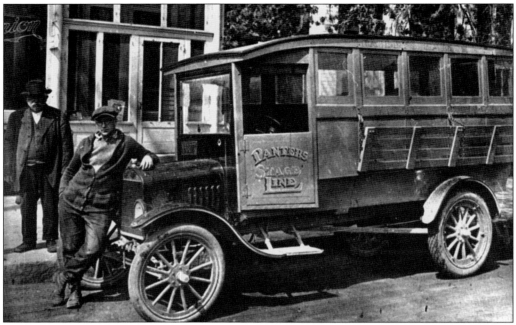

The Panter motor stagecoach, parked here in Baileys Harbor, carried passengers and mail in the early 1920s, running north from Sturgeon Bay. Passengers sat on benches like church pews, jolting painfully over the roads and ending up covered in dust. Sometimes the four-cylinder engines struggled so much on Door County's steep hills that passengers had to get out and hike to the top.

Travel north of Sturgeon Bay did not improve until after World War I, when upgraded roads brought more tourists. Until then, roads had been little better than rough pathways. Winter travel, even over the areas where road-builders had scraped bare a track for a so-called "corduroy road," (a row of logs filled and covered with a mix of sand, mud, and tiny stones) was especially challenging.

Two

EARLY DAYS AND THE TWO STEEPLES

When European immigrants started coming to settle on the Door Peninsula, most had little interaction with Native Americans. The tribes that had previously lived on the peninsula—the Winnebago, Menominee, and Potawatomi—had largely moved on before the advent of the new settlers. This group is photographed on a fishing trip in North Bay, around 1890.

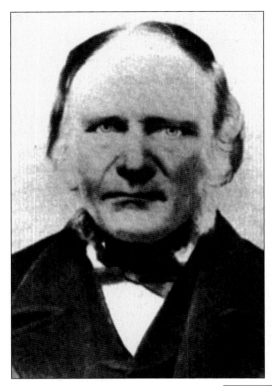

At the urging of Ole Larsen (left), who was living on Eagle Island as a logger, Rev. Andreas Iverson (below) decided to lead his congregation of Moravians from a communal settlement in Green Bay to Ephraim, where each could own land. In February 1853, Iverson and three friends scouted the location. They walked three days over the ice from Green Bay to Larsen's home. There Iverson gazed on Eagle Harbor for the first time. "With delight I looked for some time and ruminated. Perhaps our beloved little congregation should be planted here on this land by the romantic bay and with the high cliff opposite so grand in appearance." Iverson and Larsen returned to Green Bay by sleigh, and Iverson bought 425 acres for $478, using a loan from Moravian Church headquarters in Bethlehem, Pennsylvania.

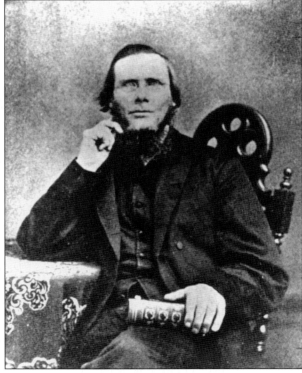

Mrs. Abraham Oneson is shown here in her later years. Oneson was the wife of one of the original settlers who walked over the ice with Reverend Iverson to determine whether Eagle Harbor would be the place for Ephraim's settlement. The family has maintained a presence in Ephraim for over a century and a half.

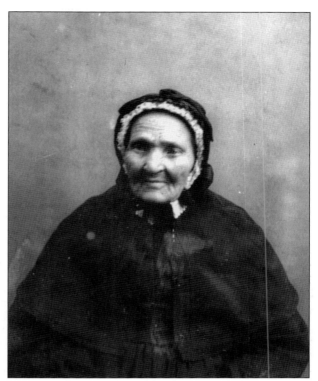

Reverend Iverson built this house for himself in 1853. Constructed in traditional Norwegian style, it had a barn for animals on the lowest level. It was used for worship until the church was built in 1859. The original two-story house is at the right, with additions to the south (left) made by Rev. J. J. Groenfeldt, the second pastor. It is now restored as a museum.

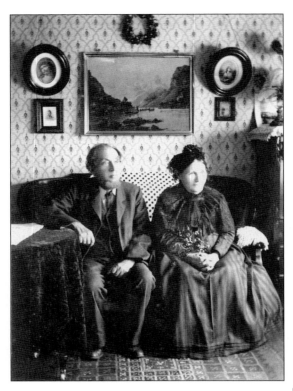

Peter Peterson (pictured here with his wife, Mary) came from Norway looking for a place to settle in the mid-1850s. Taking the advice of Rev. Andreas M. Iverson they bought property in the center of Ephraim, where Peterson became one of Ephraim's most successful businessmen. Later, Peterson was instrumental in the founding of Bethany Lutheran Church.

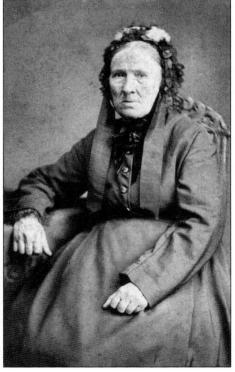

Andrea Hanson settled in Ephraim with her husband and family in 1854. Her husband died in an Asiatic cholera epidemic and was buried with eight others out on Eagle (Horseshoe) Island. Andrea was left with five children to support. Two daughters married the Anderson brothers; Greta married Aslag, and Tonetta married Halvor. Andrea's son Andrew became the village postmaster.

Greta Hanson (right) married Aslag
Anderson (below) in 1861, several years
after he and his brother Halvor arrived
in Ephraim. The brothers had emigrated
from Norway, working first in northern
Wisconsin as loggers and carpenters. At
the behest of friend and fellow immigrant
Peterson, the brothers came to Ephraim
looking for a permanent place to settle.
In 1858, Aslag and Halvor reached an
agreement with Reverend Iverson, the
Moravian minister, to purchase 166 acres
of land at its original cost. In return, they
would build a deep water pier for use by all
villagers. Aslag built the pier and a general
store and later erected his house and barn
across the road. Stretching up the hill
on what is now Anderson Lane was the
family's farm. The couple had 13 children,
10 of whom survived to adulthood.

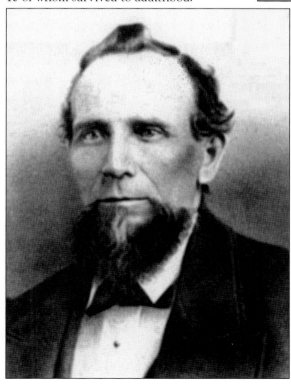

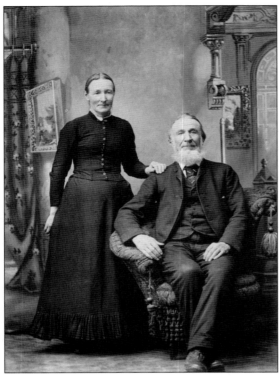

Halvor Anderson and his wife, Tonetta, are shown in their later years, posing in what appears to be a photographer's studio. They farmed on property adjacent to Aslag and Greta Anderson's property. Aslag and Halvor were brothers, and Tonetta and Greta were sisters. Descendants of both families remain in Ephraim today.

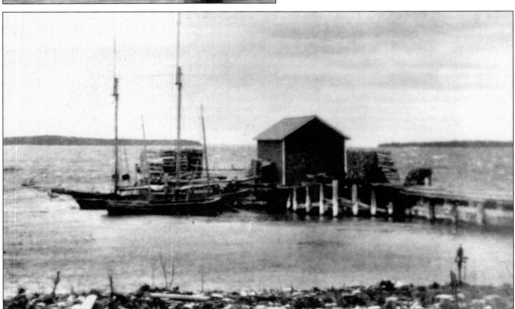

Anderson Dock and warehouse formed the engine of a tiny but growing economy built on exporting wood products by ship. Piled high on the dock were rail ties, posts, bark poles, pulpwood, cordwood, shingles, and crops such as potatoes and peas. The warehouse was destroyed once by fire and once by weather, but each time it was rebuilt. This is the earliest known picture of the original dock and warehouse, from around 1870.

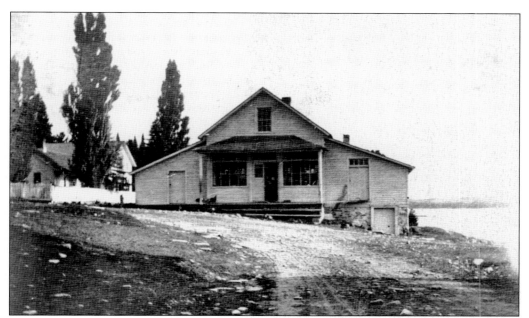

Until 1858 when the Anderson Store was built, everyday goods were hard to come by on the frontier. But the store could depend on its adjacent deep water dock to maintain its reliable stock of coffee, tobacco, sugar, salt, thread, tools, and other necessities. The two wings off the main building were storage wings, with additional storage of perishables in the basement underneath.

Cornelius Goodletson, the third white child born in Ephraim, became the father of 12 children. His father, Thomas, an immigrant from Norway, built a cabin on Horseshoe Island, which was later moved across the ice to land the family homesteaded in the area where the Ephraim condominiums now stand. It was moved again in the early 1970s and is now a museum.

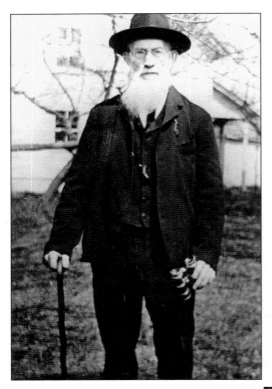

Carl Nelson arrived in Ephraim with his wife, Stina, in 1854 from Christiana, Norway. Hard workers, they built a farmhouse on 40 acres on top of the Ephraim bluff. Carl joined the 15th Wisconsin Infantry, from which he was discharged after being disabled in 1863. He returned to Ephraim, but he lived his last years in Amherst Junction, Wisconsin. The farm still remains in the Nelson family.

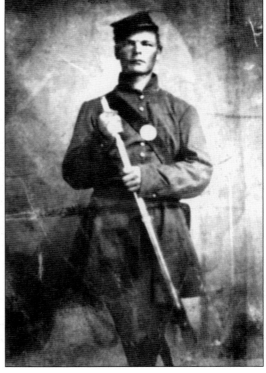

Andrew Anderson, from little Sister Bay, was born in 1842. In 1862, he enlisted in the 100th Regiment of the New York Army of the Potomac in order to get the higher bounty paid to parents of New York enlistees in the Civil War. He fought bravely, was captured, and sent to Andersonville prison, where he died in 1864. His parents never received his enlistment bounty.

Two generations of the Groenfeldt/Greenfield family served as Moravian ministers at Ephraim. In 1864, Rev. J. J. Groenfeldt (seen here) succeeded Andreas Iverson as minister of the Ephraim congregation, purchasing Iverson's house for his family. He served until 1883. His older son, John Greenfield, served as pastor from 1895 to 1902, and his younger son, Samuel Groenfeldt, pastored the congregation from 1914 to 1918.

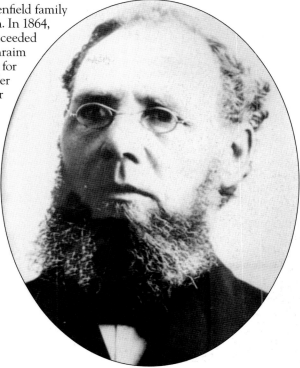

Construction of a church building on the shore of Eagle Harbor was started in 1857. It took several years to raise sufficient funds to complete it, but by autumn of 1859, the settlers had enclosed and roofed the church. They held first service in December 1859. In 1883, the church was moved up the hill to its present site on Moravia Street. This photograph is from around 1865.

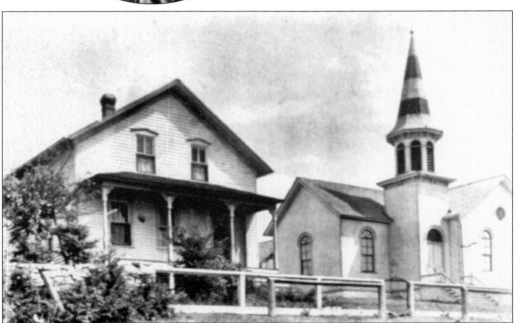

Anna Petterson was the wife of the third Moravian pastor, Anders Petterson. The couple came from Norway, arriving in Ephraim in October 1884. Anna wrote many letters to her mother in Europe outlining the difficulties of life on the frontier for a well-educated young wife. The Iverson House museum is interpreted to 1886 based on Anna's letters, which have been collected in a book, the *Door County Letters*.

During Anna and Anders' service in Ephraim, the congregation built a parsonage to house their pastors, rather than rent or buy the Iverson house, which was owned by the Groenfeldt family. The parsonage was originally built on the north side of the Ephraim Moravian Church (as it appears here), but it was subsequently moved to its present location just south of the church.

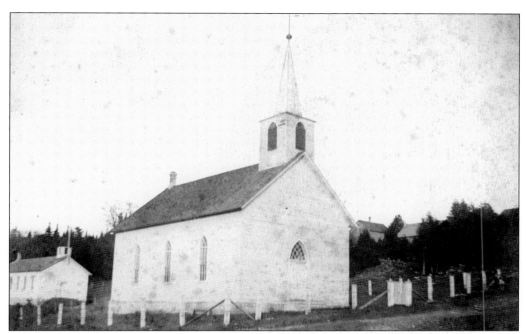

Bethany Lutheran Church (originally called Bethania Norwegian Free Church) was established after years of planning by Peter Peterson, Thomas Goodletson, and others. Organizational meetings took place at the Goodletson cabin, where it was determined that more than 60 families were interested in becoming part of the congregation. After land was purchased at a reduced price from Maria Olson, the church construction took place in 1882.

Rev. Johan Olson was the first pastor at Bethany Lutheran Church. The recent seminary graduate from Chicago was called to pastor the church on October 28, 1882, at an annual salary of $400 plus the Easter and Christmas offerings. Reverend Olson was a talented musician, poet, and writer. During his tenure from 1882 to 1892, he also organized congregations in Juddville and Ellison Bay.

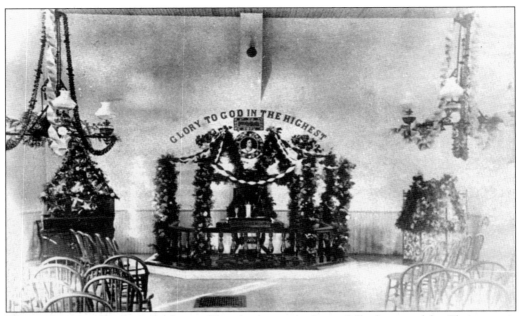

This early view of Bethany Lutheran Church, showing it beautifully decorated for Christmas, is the earliest interior photograph of the church. The Bethany Ladies Aid, organized shortly after the church's establishment, was responsible for scrubbing the floors and chairs after services, since worshippers were usually muddy and dusty from travel on primitive roads. The acquisition of pews early in the 20th century was hailed by the ladies as a great work saver.

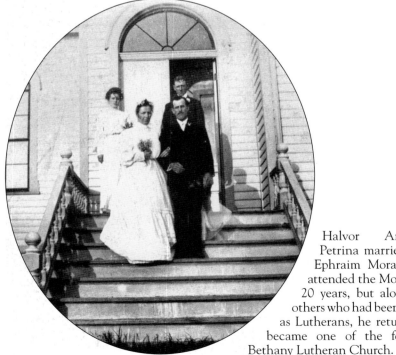

Halvor Anderson's daughter Petrina married Sam Rogers in the Ephraim Moravian Church. Halvor attended the Moravian church for over 20 years, but along with a number of others who had been raised in Scandinavia as Lutherans, he returned to his roots and became one of the founding members of Bethany Lutheran Church.

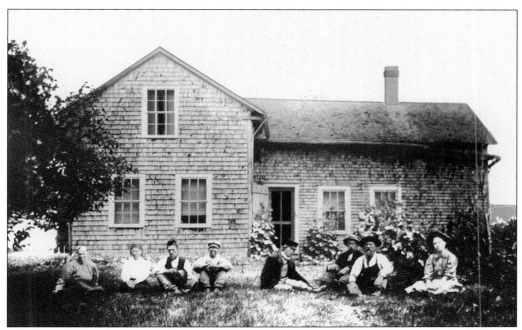

Founding Bethany Lutheran Church member Ole Hanson moved to Ephraim to work as a logger, where he met his wife, Mary, at the logging camp. They married in 1875 and bought 80 acres of stump land along what now is Gibraltar Road. After grubbing out countless stumps, they built a shingled farmhouse for their growing family. The family is shown above in front of their house.

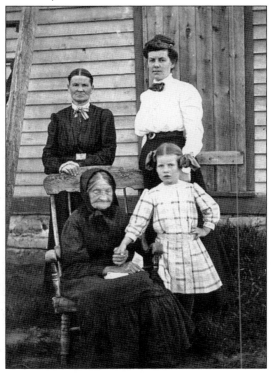

Seated in front of her farm home is Johanna Ohman, wife of Sven Ohman. She and her husband were Norwegian immigrants and founding members of the Bethany Lutheran Church congregation. Hedvig Goodlett, their daughter (standing behind her chair), married Cornelius, son of Thomas and Kirsten Goodletson. Descendants of both Goodlett and Ohman families are still members of the Bethany Lutheran Church congregation.

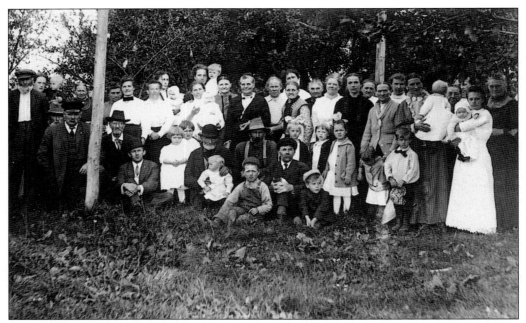

The Bethany Ladies Aid summer picnic was an annual event, with grandfathers of the congregation's young mothers traditionally called into service for transportation to and from the celebration. Food and games provided fun and a respite from otherwise relentless work. This picnic was held at the home of Wilhelmina Seiler in the summer of 1912. (Courtesy of Thelma Erickson.)

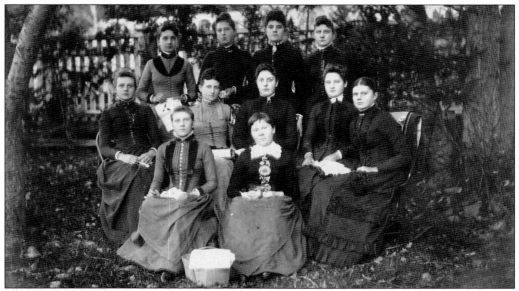

Ephraim Moravian Church's "Willing Workers" were photographed about 1895 by Sophia Lindem. They are, from left to right, (first row) Olive Anderson and Gusta Aslagson; (second row) Lizzie Anderson, Anna Valentine, Eugenia Smith Thorp, Delia Torgeson, and Charlotte Amundson; (third row) Issie Thorsen, Hannah Valentine, Jennie Thorson Amundson, and Munda Anderson. The ladies did sewing and other projects to benefit the church.

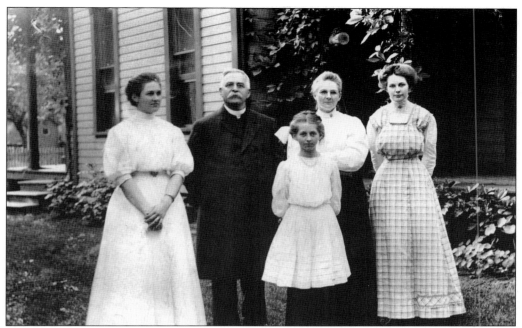

Rev. Calvin Kinsey served the Ephraim Moravian Church from September 1902 through October 1908. He and his family are shown posing beside the parsonage. They are, from left to right, Helen Kinsey Simmers, Reverend Kinsey, Martha Kinsey, Mary Luckenbach Kinsey, and Katherine Kinsey Johnson, around 1910. (Courtesy of Marianne Kellman.)

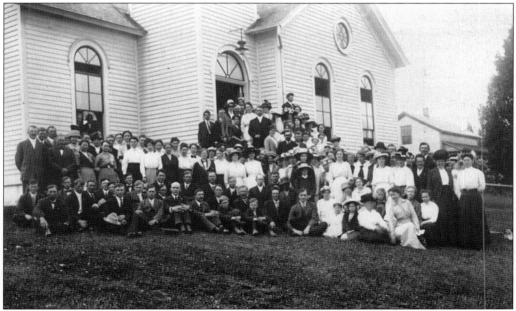

The Annual Convention of the Door County Sunday School Association is shown on the front lawn of Ephraim Moravian Church in the summer of 1914. Standing at the far left is Anders Petterson, who was serving as the church's pastor for a second term (1910 to 1914), after initially serving from 1884 to 1895.

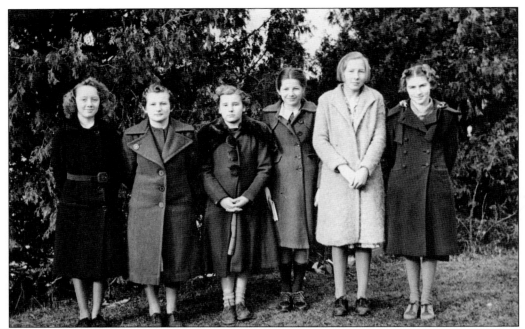

This picture of Lizzie Anderson's Sunday school class was taken at Christmastime, 1938. Members of the girls Sunday school class from left to right are June Bastian, Mildred Kemp, Peggy Paschke, Margaret Pluff, Alberta Seiler, and Betty Thorp. Lizzie Anderson was the Ephraim Moravian Church secretary for many years, as well as a faithful Sunday school teacher.

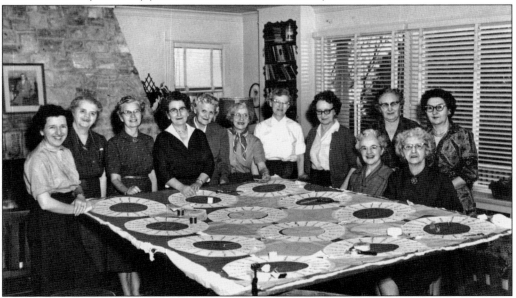

This quilt project was completed by the ladies of the Ephraim Moravian Church and is now on display at the Anderson Store Museum. They are, from left to right, Peggy Jones, Bertha Thorp, Elizabeth Manson, Laurel Knudson, Maybelle Holland, Kittie Valentine, Helen Backstrom, unidentified, Grace Helgeson Scanley, and Elda Helgeson. Seated are Eleanor Rhind and unidentified.

Three

ECONOMIC GROWTH

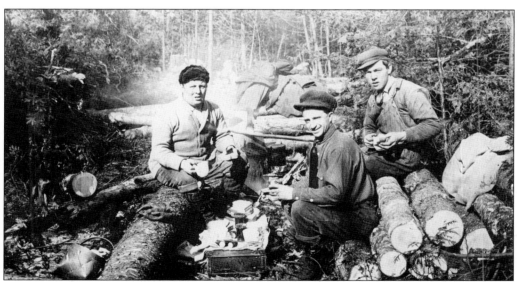

Bitterly cold winters made subsistence a daunting challenge for the immigrants who founded Ephraim in 1853. Fish from the waters of Green Bay were one of the few reliable sources of food. When fishing was less productive 40 years later, fate introduced the villagers to the potential of tourism. Hotels that could accommodate 40–190 people appeared. Logging (above) was the first step in clearing land so that farms and homes could be established. Pictured are, from left to right, Otto Staver, Albert Warley, and Ted Staver. (Courtesy of Augusta Brungraber.)

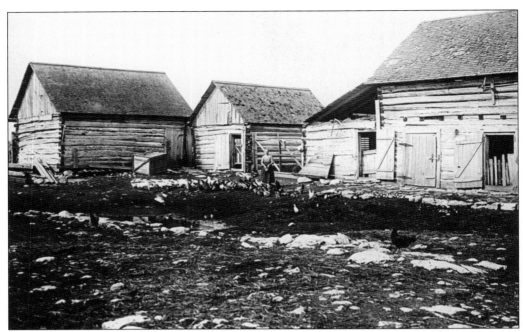

While many Scandinavian farms were located in the area just south of the village, German farmers clustered on the high land east of the village. Many of their farms were on stump land that had been left behind after being logged over. It often took years to remove enough stumps and rocks for the farm to prosper. Here Marie Staver is feeding chickens on the family's farm on Highway Q. (Courtesy of Augusta Brungraber.)

Karl Seiler, an immigrant from northern Germany, established an 80-acre farm at the eastern edge of Ephraim with his first wife, who died. This is purportedly a wedding picture of Karl and his second wife, Wilhelmina, along with his youngest child, Bertha, by his first marriage. The children went to the German Lutheran school, but the family attended the Ephraim Moravian Church.

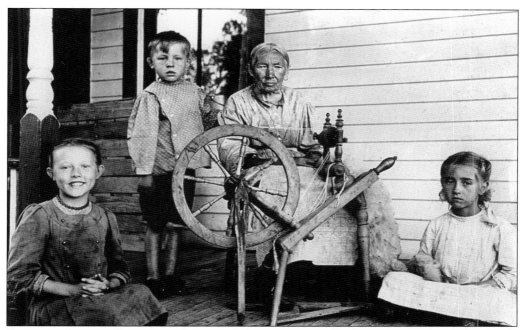

Ernestine Stoewer (later Staver) sits with her spinning wheel on the porch of the family farmhouse in the German settlement east of the village. Although the Norwegians, who lived along the shore, depended heavily on fish to survive, the Germans tended to focus on farming as they did in their respective homelands. (Courtesy of Augusta Brungraber.)

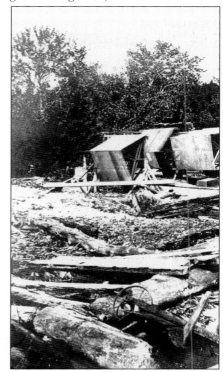

Commercial fishing became an important "cash crop" for the Scandinavian fishermen. Fish were plentiful and could be preserved by salting in order to ship them out on the schooners that came into Anderson Dock. The square frames shown here were used to roll up and dry the commercial fishing nets.

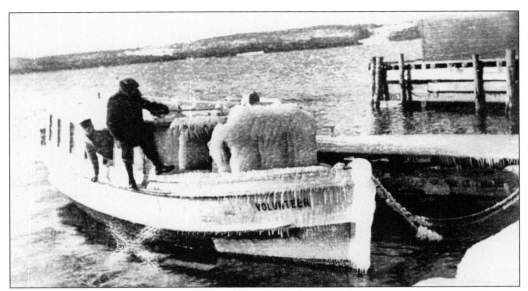

The challenge of commercial fishing, which was vital to Ephraim's early economy, is most evident in extreme weather. Here, probably in late November or December just before the bay had frozen, fishermen pull into Anderson Dock with their boat dripping ice. The fish were certainly kept cold, as were the fishermen.

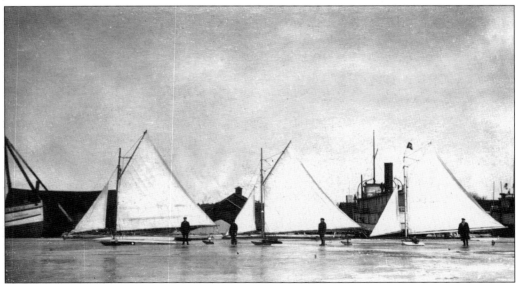

Three sail sleighs stand on frozen Green Bay near Marinette. Without a rudder, steering was done by trimming the sail. The one- and two-passenger sleds often pulled another sled that held gear for ice fishing. Commercial fishermen used a "gill net" inserted through one ice hole and probed about 30 feet to another so the net could be shaped. Marinette was a prime market for fish and other goods.

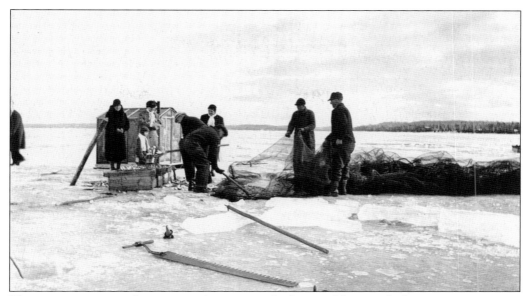

The ice was a center of activity in the winter, whether ice fishing with shanties or cutting ice for commercial or resort ice houses with an ice saw drawn by horses. Later ice was sawn with chain-style commercial saws. Note the shanty in the background and the long ice saw lying on the ice.

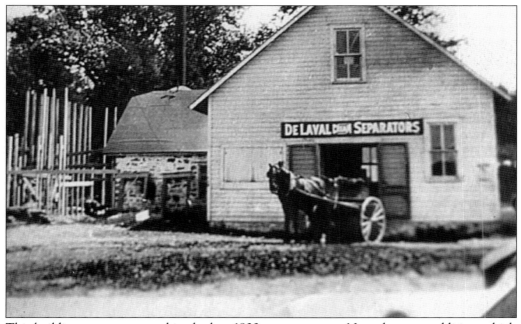

This building was constructed in the late 1800s as a creamery. Note the stone addition, which served to keep the cream cool. Farmers from the German settlement to the east and the Scandinavian farms to the south sold their milk to the creamery to be made into cheese. Some milk was kept for the family, and many housewives churned and sold their own butter to make more money.

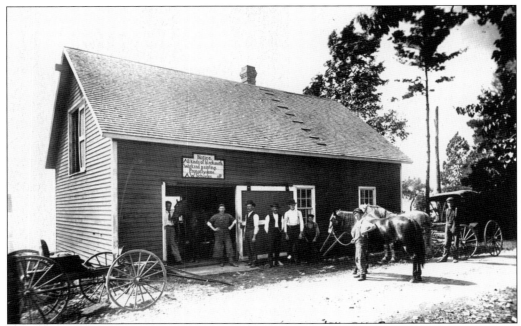

Art Schuyler's blacksmith shop stood on the shore across from what later became the Pine Grove Hotel. Each town usually had a blacksmith to repair buggies and harnesses, along with fashioning horseshoes and metal pieces for various uses by carpenters and barrel makers. After the shop was vacated, it stood empty for many years, finally burning to the ground.

This sawmill stood on the shore just north of Wilson's Ice Cream Parlor. It was built and operated by George Larson, a sought-after carpenter who had immigrated to this country from Norway. He and his wife (also a Norwegian immigrant) homesteaded near Maple Grove Road, where they raised eight children.

Maurice (Maurie) Larson, youngest of George's children, was proud of being Norwegian. Known for his sense of humor and generosity, he lived his entire life in Ephraim. He operated a filling station and garage across the highway from his sister Hilda Larson Paschke's establishment, the Brookside Tea Garden. The stone gas station was designed by well-known architect William Bernhard. (Courtesy of Paul Burton.)

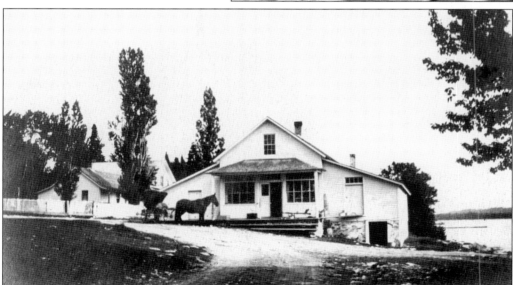

The Anderson Store was important as a lifeline for goods from the outside world in the early days. It was also a center of Ephraim commerce from its opening in 1858 through the 1940s. Barter was popular in the early days before visitors started bringing cash into the community, and local and summer residents were often "on the books," settling their bills before the end of the summer season.

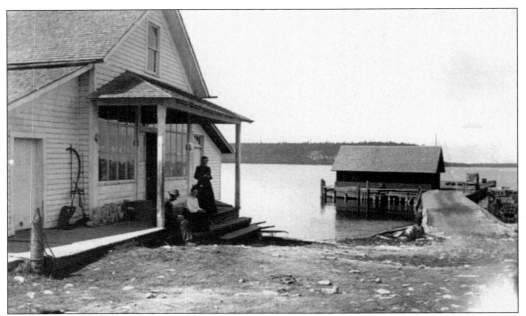

At left is the Anderson Store in the late 1800s. The warehouse, shown at the end of the dock, is the second structure built there. The original warehouse was destroyed by a windstorm; this one was destroyed shortly thereafter by fire and replaced by a still larger one that still stands today. Most cargo going into or out of the village passed through this building.

Nine of the 10 surviving children of the Aslag Anderson family, Ephraim's most successful business people, are shown here as young adults. Munda is in front with her sister Lizzie at far left. Both of them helped run the store. Next to Lizzie are, from left to right, Cordelia (Hogenson), Elmer, homemaker Olive, and dockmaster Adolph. On the porch are Frank (who ran the farm), Agnes (Torgerson), and Elvira (Egeland).

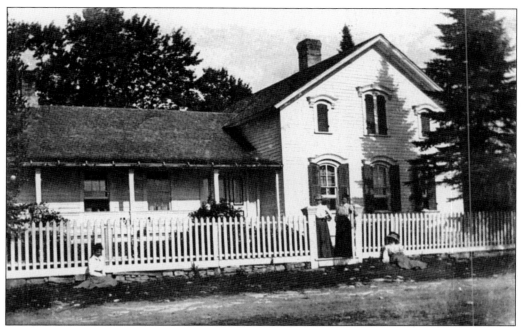

The Anderson family home was built in the 1860s to replace the log home originally constructed in their east meadow. The Andersons often hosted guests in their home—visitors that had been stranded by bad weather or other difficulties—as well as relatives and friends who came to visit. Lizzie, Munda, Frank, and Olive lived most or all of their lives in this house, happy with each other's company.

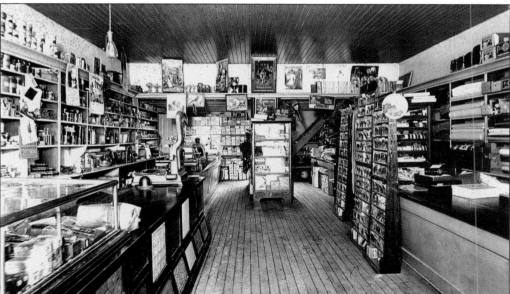

The interior of the Anderson Store looks virtually identical to this picture today. The Andersons never put anything on sale and never got rid of anything, so when the Ephraim Foundation began restoring the building as a museum in the mid-1960s, nearly all the fixtures and products were to be found in the attic, even brand-new, 1920s ladies button shoes.

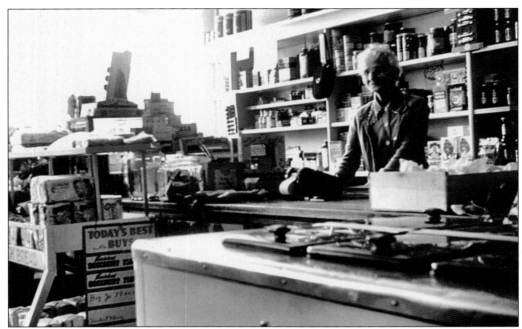

As the village grew, so did the merchandise offerings in the Anderson Store. Note the emergence of refrigeration for "bought" ice cream, milk, and meat products in the later years. The Andersons' ability to evolve, coupled with a sense of community welfare and integrity, enabled the store to endure the longest of the three general stores in this tiny village. Munda Anderson is shown behind the counter.

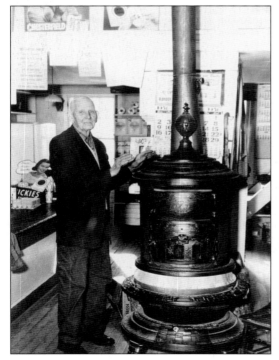

Adolph Anderson, for years the village's most eligible bachelor, warms his hands on the potbellied stove in the rear of the store. Behind the stove was located the shoe department. In 1906, Adolph married Tillie Valentine, a widow, who was one of the first to offer lodging and meals at her Stonewall Cottage. She and several other families were the founders of Ephraim's emerging tourism and summer resident economy.

Adolph is pictured splicing line in front of the store. While his sisters ran the store, Adolph was on the outside managing the dock, the warehouse, and all of the marine activities that took place there. Adolph was highly respected as a businessman and was a source of assistance and support to local residents and to "summer people" who owned boats or rented boats from him.

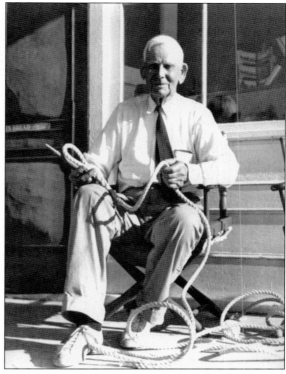

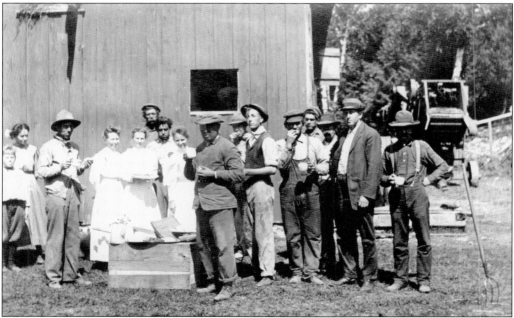

The Anderson Barn, across the highway from the Anderson Dock, provides the backdrop for this group of threshers taking a break and being served coffee and refreshments. Threshing crews traveled from place to place harvesting one farm's crops after another, since the equipment was too expensive for individual farmers to own.

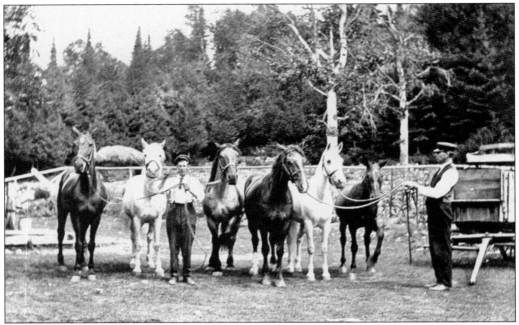

The Anderson Barn was used in the 1920s and again in the 1940s as a riding stable. A man who is probably Charlie Strege (left) and an unidentified man hold the reins of six horses. The barn is now open to the public as a museum for historical exhibits, and areas where the horses gnawed away at the boards in their stalls are still evident.

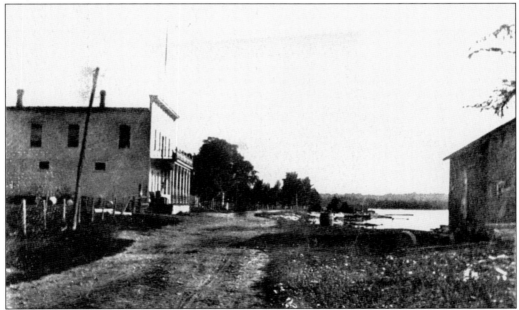

Shown on left is the J. Hanson General Store and post office. It was built in approximately 1860 by James Hanson's adoptive father, early businessman Peter Peterson. It was the second of three general stores, unusual for a small village. After the store closed, it became a hotel, responding to Ephraim's emerging tourist economy.

Jacob Smith (left) founded Smith's General Store and built his family home across the street. The store was successful, and his son Clarence continued to operate it for a number of years while one of his daughters, Eugenia, founded the Eagle Inn. The family home became Dr. William Sneeberger's office and is now the Ephraim Inn Bed and Breakfast.

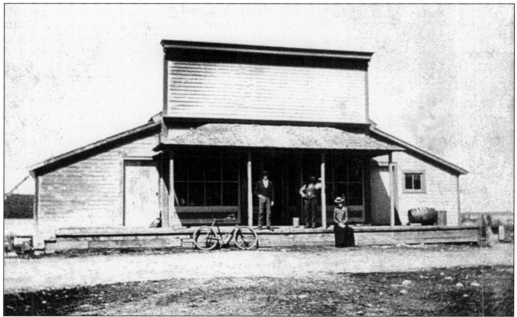

Smith's General Store (1880s) was located on the shore immediately north of the present South Shore Pier and Boat Rentals. In about 1927, it was sold to Glen Thorp and moved across the street to become the Bay View Grocery (see the next page). Subsequently it was operated by the Nippert family and later by Cecil and Nancy Panter.

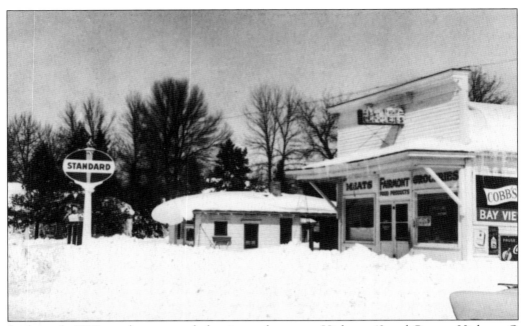

In the early 1930s, at the corner of what is now known as Highway 42 and County Highway Q (Church Street), stood a filling station operated first by Glen Thorp and then a succession of others. Customers would predetermine how many gallons they wanted and then pump it into their automobiles. The store building, on the right, was the Bay View grocery store.

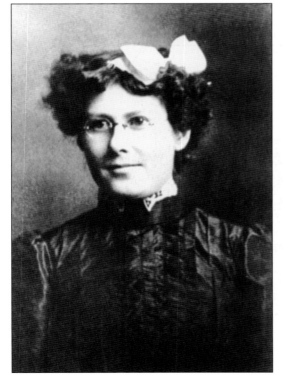

Ida Seiler Sohns was 1 of 12 Seiler children. The Seilers farmed in what was called the "German Settlement" immediately east of the village. Ida and her husband, Arnold Sohns, established the legendary Sohns' Grocery Store, which was Ephraim's principal grocery source for decades. Later their son Bill and his wife, Helen Hoeppner Sohns, took over and operated the store for many years.

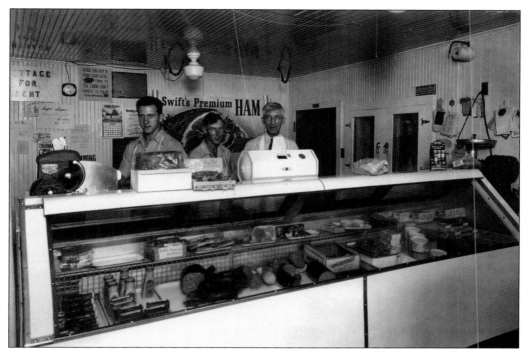

Arnold (above) is shown behind the meat counter of Sohns' Grocery Store, with his sons Glen (left) and Bill. Located downtown on Church Street (now County Highway Q), it featured the first chicken-plucking machine in the area—of great use to prepare the many chickens required by the local hotels for their Sunday dinners. Reports were that the feathers flew in clouds behind the store as the chickens were being processed. (Courtesy of Sohns family.)

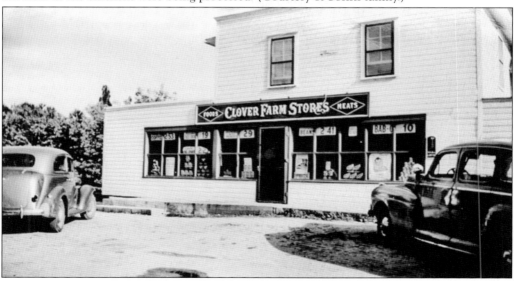

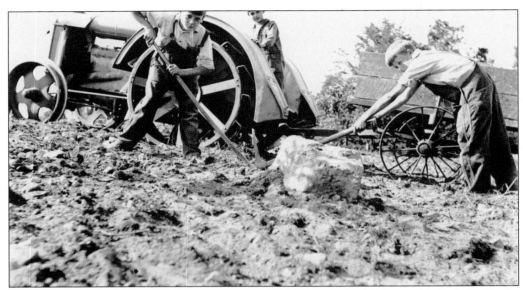

The Fardig family, who spent their summers in Ephraim in the 1920s, established the Fardig Cherry Orchard on top of the bluff in Ephraim, along County Highway Q. Although most of the land was cleared, some stumps and many rocks had to be removed before the land was ready for planting. The young Fardig twins, Oliver and Sheldon, were put to work picking rocks. Above is just one of the many sizeable rocks they picked. The rocks were loaded onto wagons and used to build long stone fences. Below, the small man sitting on the ground is the dynamiter who was in charge of blasting a hole in the limestone escarpment for each tree. The family operated the orchard for approximately 25 years, which is about the lifespan of cherry trees. (Courtesy of Fardig and Whiteley family.)

Four

SCHOOLS AND DAILY LIFE

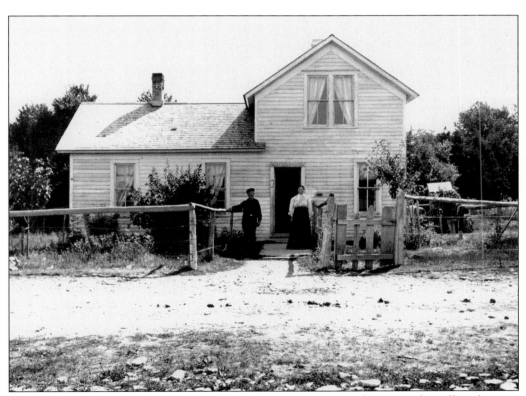

Survival in early Ephraim was a struggle. During ensuing years, however, the village became more habitable with the establishment of a post office, a school, and medical care. As of 2007 the village of Ephraim remains the only dry community in Wisconsin. Here Andrew Hanson and his wife stand in front of their home, which was also the post office until 1906. He was appointed postmaster on March 14, 1894.

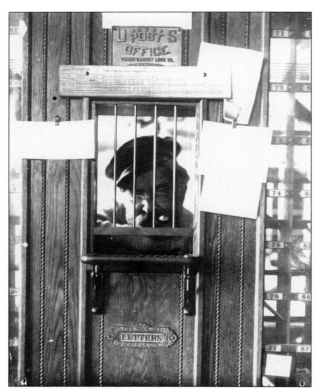

Between 1861 and 1983, Ephraim had only four postmasters. Hans P. Jacobs was first, followed Andrew Hanson (seen here). Between 1915 and 1951, Sam Hogenson was postmaster, and Bert Thorp took over until 1983. The original post office consisted merely of a box on a shelf. Over the years, it moved from the Jacobs' home, to Andrew Hanson's home, to James's Hanson's General Store, then to the Ephraim Village Hall in 1925.

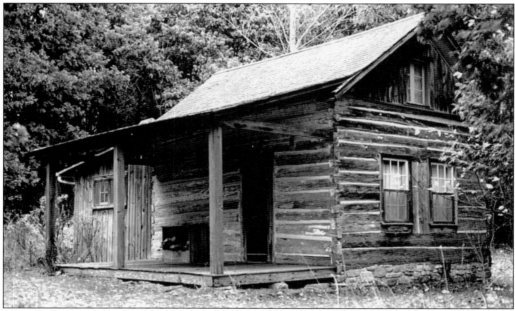

Rev. Andreas Iverson was the first superintendent of schools in northern Door County. Classes were taught in student's homes, rotating regularly, as well as in the Moravian parsonage. The first teacher was Ole Larsen's daughter, Pauline Larsen Johnson. The first school, the small log structure shown here, was built in 1869 at a cost of $130 and is still in use as a private cottage.

Above is the oldest known picture of pupils at Ephraim's first school, around 1880. It was probably taken on the hill behind the school. Note the dropped sleeves on the girls' dresses and the parted, skimmed-back hairstyles that help to date this picture. (Courtesy of Lila Field.)

The original German Schoolhouse on Highway 57 north of County Highway Q was built in 1878. Later it received an addition, and after it closed, it became a cheese factory. It is now a gift shop. The Liberty Grove School, on the corner of German Road, was built in the early 1920s and is now a private home. The school class above is from around 1880.

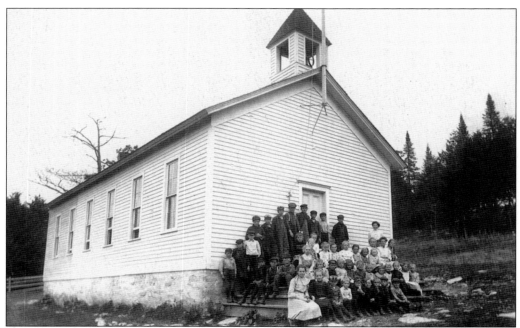

The second school building in Ephraim was a frame structure built in 1880 to accommodate the growing number of students. The school was originally little more than half of its current size, the addition being put on before 1900. The largest number of students taught by one teacher was 69. Above is a class picture from around 1900 with longtime teacher Laura McSweeney standing at the far right. Note there is no access to the basement, while the later photograph (below) shows a door to the basement where a wood furnace was installed, with metal grates in the middle of the schoolroom floor above it. It replaced the original potbellied stove in the classroom.

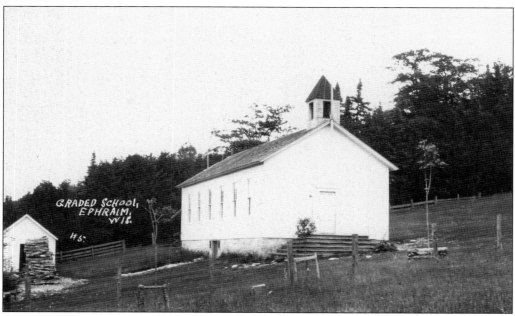

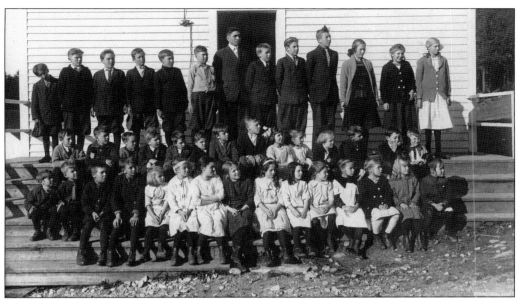

Above is a photograph of the 1913 class. They are, from left to right, (first row) three unidentified, Hollis Wilson, Mildred Peterson, Edith Peterson, Myrtle Grasse, Marjorie Gustafson, Julia Rogers Volkmann, Annie Rogers, Olga Ohman, Malinda Knudson, Elsie Anderson, Effie Didrickson, and Caroline Olson; (second row) Carroll Nelson, Arni Didrickson, Arthur Johnson, Maurice Larson, Ivar Holand, Donald Langhor, Carl Wilson, Milton Langhor, Annie Beard, Helen Olson, Louise Anderson, Harold Holand, Harold Jepson, and Walter Barnes; (third row) William Anderson, Alfred Evenson, Maynard Grasse, Marvin Oneson, Eugene Helgeson, Robert Larson, teacher P. Meumier, James Groenfeldt, Orvis Wilson, Alfred Oneson, Lillian Evenson, EllaMae Goodlett, and Esther Olson. In the image below, long-time teacher John Brann stands at the right in this class picture, around 1915.

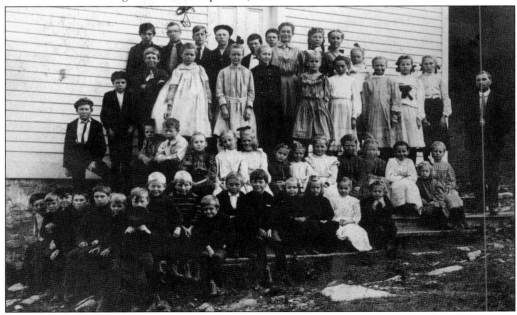

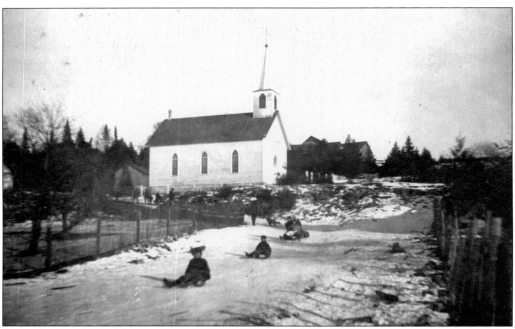

All students love recess, and Ephraim students had the advantage of a built-in sliding hill adjacent to their school for winter fun. Above, the winter of 1910 provided opportunities to sled and ski down County Highway Q, which at that time led straight down the hill, across State Highway 17 (now 42) onto the ice. Ted Hoeppner, former teacher, recalled that he once slid down the hill so far onto the ice that he was late to call his students back to class after recess. The school is barely visible on the left. In 1936, 26 years later, a toboggan provides fun for four boys, who are, from left to right, Hilton Peterson, Jim Strege, Junior Olson, and Bert Thorp.

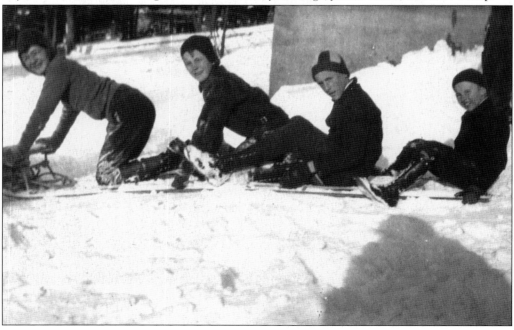

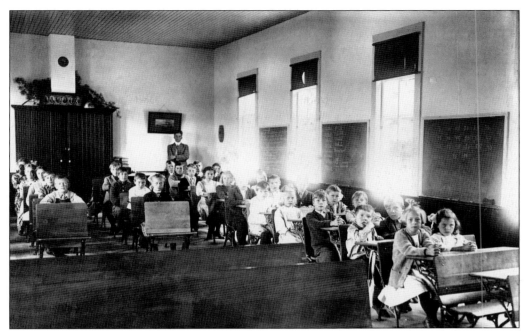

This is the only known early photograph of the interior of the Ephraim School, from around 1920. By this time, the school had a coal furnace in the basement (note the chimney in the back with the empty hole for a potbellied stove pipe). The children shared desks and came up to the front recitation benches for classes.

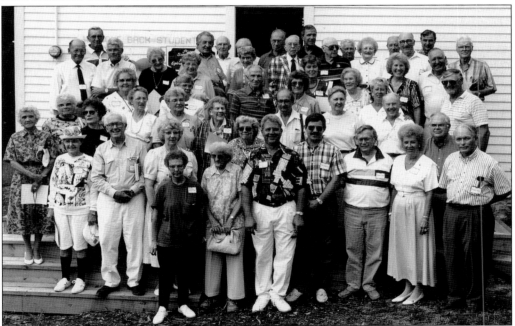

In 1993, 56 former students attended a reunion organized for all those who had attended the Ephraim School. It was organized by Nancy Davis, sponsored by the Ephraim Foundation, and took place at what is now the Pioneer School Museum. (Courtesy of Nancy Davis.)

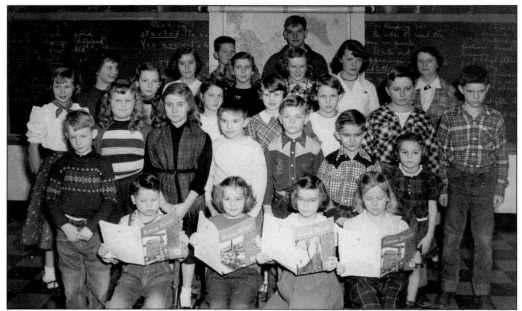

This is the class picture of 1953, which was also Ephraim's centennial year. They are, from left to right, (first row) Paul Kodanko, Julie Stenzel, Carrie Mayhew, and Judy Kwaterski; (second row) Ernie Anderson, Lois Nelson, George Larson, Johnny Kwaterski, Danny Nelson, and Ann Hoeppner; (third row) Karen Sohns, Janice Smith, Patty Holand, Betty Hoefert, Eileen Hoefert, Dick Olson, and Karl Kodanko; (fourth row) Kathryn Elquist, Barbara Holand, Linda Mayhew, Elaine Knudson, Joan Sohns, Judy Jensen, and teacher Helen Hoeppner Sohns; (fifth row) Richard Kodanko and Roger Larson.

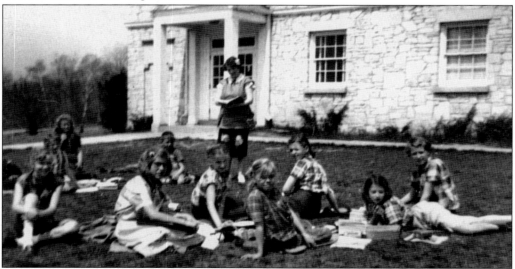

In 1948, the village saw the need for an upgraded school facility and constructed a building designed by William Bernhard at the corner of Norway Street and County Highway Q, with two levels and a kitchen. Talk of selling the old school compelled Helen Hoeppner Sohns to consult with summer resident Warren Davis Sr. about preserving the structure, resulting in the creation of the Ephraim Foundation to save the building.

Dr. Gustav (Gussie) Egeland practiced medicine in Ephraim in the early 1900s. In 1906, he married Elvira Anderson, and adopted a daughter, Rita, who died in childhood. Subsequently he built "People's Hospital" in Sturgeon Bay and rebuilt the hospital after it was destroyed by fire in 1920.

Dr. William Sneeberger moved to Ephraim with his family to practice medicine in 1921 and continued his practice until 1967. He had two sons, William Jr. and Robert (Bob), and a daughter, Mary Lou (Hartl). His wife, Dorothy, was a nurse and helped him in his practice, delivering many babies at their home/office. Sneeberger was awarded the honor of being the first Fyr Bal chieftain in 1965.

The old creamery building on Church Street was chosen to house an electric generator in 1916. The generator was started up before breakfast and provided power for resorts, cottages, and homes all day. At 9:30 p.m., a whistle would sound to remind residents that the lights would go out in half an hour, and they should light their kerosene lanterns. Operation ceased in the early 1930s, when regular electrical lines were strung.

Architect William Bernhard was born in Saint Petersburg, Russia, and grew up in Germany. He immigrated to the United States in 1910. Bernhard worked in Chicago as an architect with Frank Lloyd Wright, later moving to Ephraim where he had an office in his home. He designed many imaginative stone buildings in the northern end of Door County.

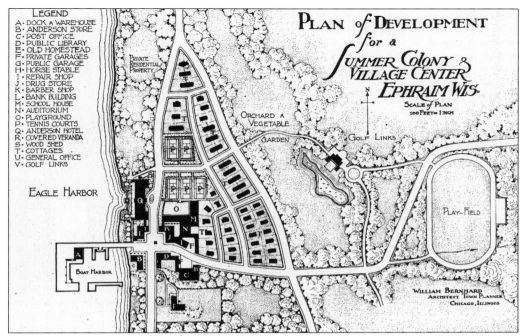

PLAN of DEVELOPMENT for a SUMMER Colony & VILLAGE CENTER EPHRAIM WIS.

SCALE of PLAN
100 FEET= 1 INCH

WILLIAM BERNHARD
ARCHITECT TOWN PLANNER
CHICAGO, ILLINOIS

One of Bernhard's flights of fancy was this "Plan of Development" for Ephraim, designed before 1932 when he was still living in Chicago. Included in the design are a barbershop, horse stable, auditorium, bank, and golf links, with most development located to the north and east of the existing village.

Bernhard's original 1924 design for the Ephraim Village Hall featured both Germanic and Nordic influences, with heavy carvings gracing his signature stone construction. Although Bernhard's designs were nearly always inventive and artistic, they were often expensive to build. The village hall, like a number other Door County structures he designed, ended up being redesigned by another architect. (Courtesy of Village of Ephraim.)

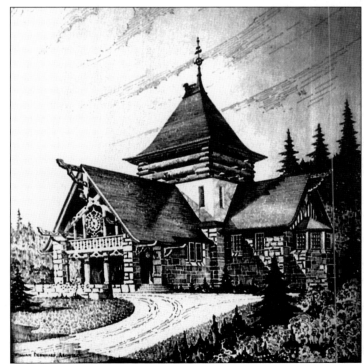

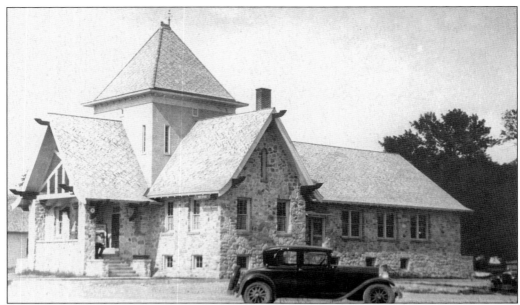

Here is the Ephraim Village Hall as it was actually built, a variation of William Bernhard's original design, which was reworked by county architect Fred D. Crandall. The building was finished in 1926 and housed the post office for many years. A number of features included in Bernhard's plans were retained, including modified elements of the roof design and simplified carvings to lend the northern European influence.

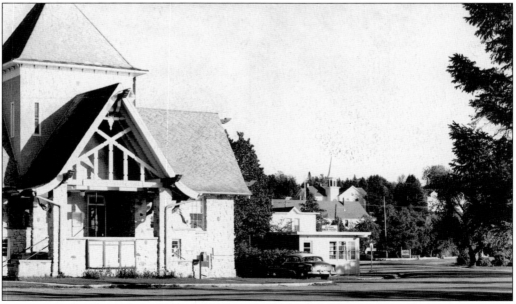

Prior to the building of the Ephraim Village Hall library addition, the Ephraim Information Office was housed in this small temporary building on the south lawn of the hall. There friendly guidance was dispensed to visitors looking for restaurants, activities, and lodging throughout the village. It occupied half of the library addition from the early 1960s until the village opened the current visitor's center building in 1988.

Dr. David Stevens, president of the board of the Rockefeller Foundation for many years, was a long time summer resident along with his wife, Ruth, and his daughters, Anne Stevens (Hobler) and Barbara Stevens (Monroe). The Stevens were leaders in the effort to provide funding for a library addition to the Ephraim Village Hall, and their family remains involved in the community during the summer season.

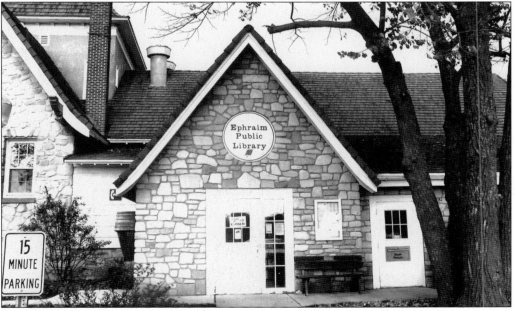

The addition housing the library and new information office opened in 1961. Previous locations for the library included the barbershop (housed for a number of years in the village hall), the hall's attic (which was outfitted with built-in shelves), and the basement (which flooded when the water was high). Verra Sauer was the first librarian in the new library, which is part of the Door County Library System.

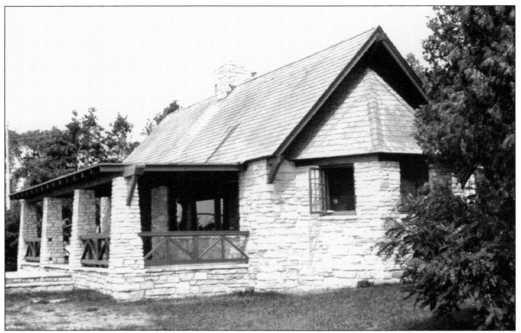

The building that now houses the Ephraim Visitor's Center was built in 1926. It was originally designed by William Bernhard as a service station and refreshment pavilion for Milton Hanson. It later became a restaurant operated by Al Smith, who married Olive Hanson. In the early 1980s, it was operated as an art gallery. The Village of Ephraim bought the building in 1986.

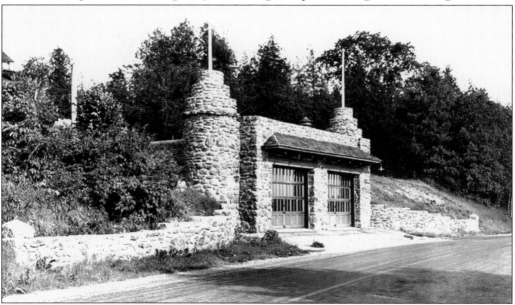

The original Ephraim fire station on Highway 42 was designed by Bernhard and built in 1934 to house the new fire truck purchased by the Village of Ephraim. Vacated in 1990, the historic building is in the process of being renovated as a museum. The antique fire truck is also being restored and will be housed in the station.

Five

RESORTS AND TOURISM

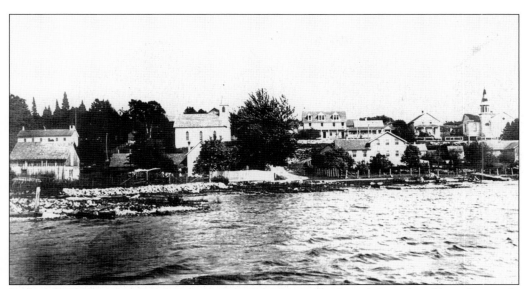

In the late 1800s, steamships began arriving at Anderson Dock, and the railroad brought people up to Sturgeon Bay, where they could then board a horse-drawn stage to northern Door County. Norwegian immigrant Fordel Hogenson became the proprietor of Ephraim's first hotel, Evergreen Beach, established in 1897. This scene shows downtown Ephraim just after 1900. Anderson Hotel is at the top middle and Hillside Hotel at the lower right. Other landmarks are Bethany Lutheran Church on the left and the Moravian parsonage on the far right.

Fordel Hogenson is shown here with his first wife, Lene, with whom he had seven children during their 12-year marriage. While they were married, Fordel worked as a sailor. After Lene died, he married his housekeeper, Toneta Toneson, and began farming as well as sailing, until the couple turned their home into a hotel.

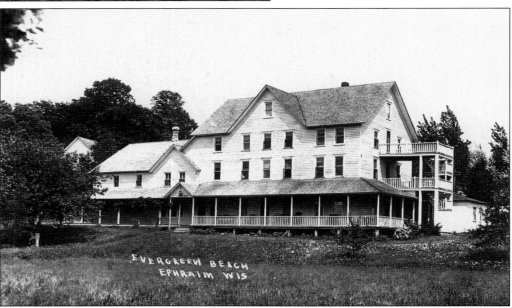

Fordel and Toneta Hogenson expanded their family home (left end of building) until they could accommodate 50 people in 22 guest rooms at the Evergreen Beach Hotel. The family operated Evergreen Beach Hotel until Fordel's stroke in 1920, when widower Peder Knudson sold his own hotel and came to assist. Peder married the Hogensons' daughter, Dena, repurchased his Knudson House, and the Hogenson family resumed operations in 1928.

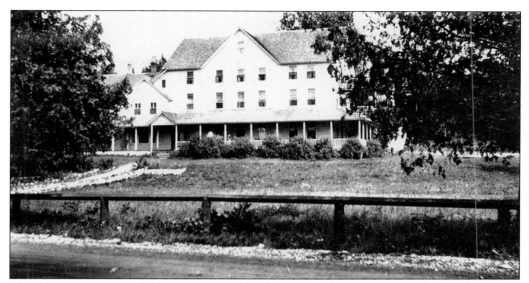

This later photograph of Evergreen Beach Hotel shows the beginnings of its famous front walk lined with pink petunias. The guest rooms on the second and third floors were furnished simply with a wooden bed, a dresser, and a washstand. Three meals a day were served in the first-floor dining room. Guests paid $5 per week for all three meals and lodging.

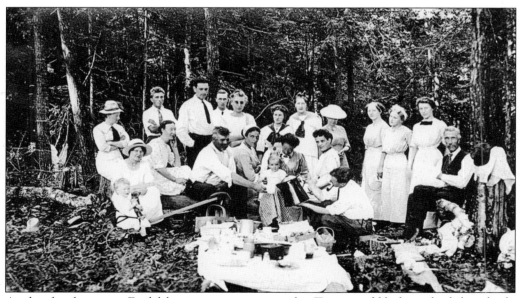

At this family picnic, Fordel leans against a tree, right; Toneta is fifth from the left in back; and Dena Hogenson Knudson is sitting, hand to face. The hotel was operated by Fordel's son Herman and his wife, Lillie, from 1928 to 1944, when they sold to Floyd and Laurel Knudson. In 1969, the Knudsons sold to their daughter Joyce and her husband, Glenn Gerdman. Extensive remodeling in 1976 created spacious motel units.

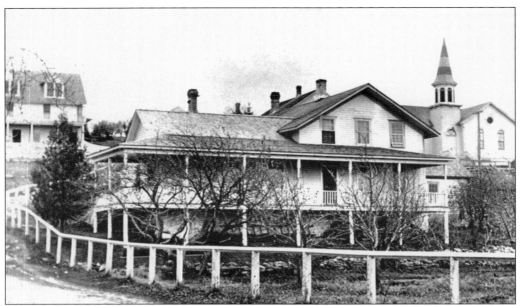

Morton and Maria Olson purchased a four-room log cabin from Rev. Andreas Iverson in 1866. Their son O. M. married Serena Christiansen and moved in with his parents in 1884, building additional bedrooms as their family grew. They rented the rooms to guests in the summer, and the building became the Hillside Hotel in 1901. A corner of the Anderson Hotel is visible, upper left, and the striped Ephraim Moravian Church steeple, upper right.

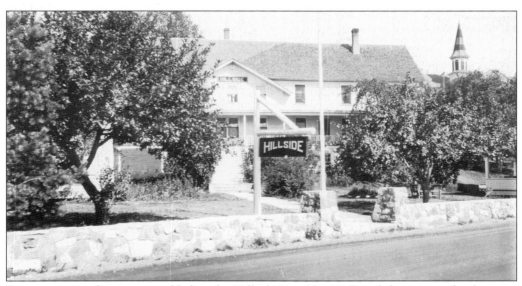

A two-story south wing was added to the Hillside Hotel by 1915, and the summer kitchen was moved to the front to become a four-room cottage, with another cottage built across from it. The lovely stonewall in front was present by the 1940s. The hotel eventually included 13 guest rooms and a big front porch. The family moved out every summer to make room for paying guests.

Serena had worked as a housemaid for dock and store owner, Aslag Anderson, before her marriage to O. M. The couple had five children who all worked hard at the Hillside Hotel, especially after O. M.'s death in 1921 at age 60. Serena did almost all the cooking on a wood stove well into her 70s. She died in 1948 at the age of 82.

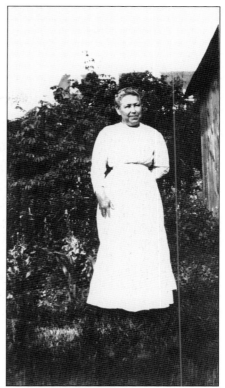

Guests are enjoying Serena Olson's cooking in the Hillside dining room. Though a rather modest establishment, it was clean and served fresh food from the Olsons' orchards and gardens. In 1969, it was sold to Dean and Evadne McNeil, whose son David and wife Karen took over in 1983. James and Clare Webb bought it in 2001 and turned the 12 rooms and two shared baths into a five-room bed and breakfast.

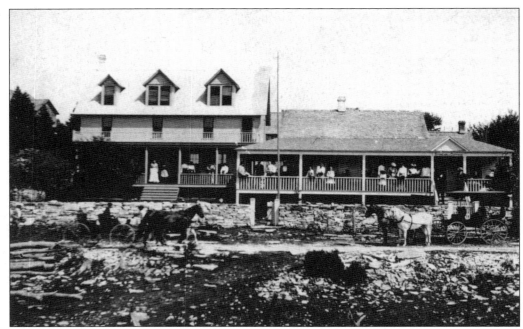

Around 1902, Tillie Valentine is standing on the porch of the recently built part of her hotel on Ephraim's Upper Road (now Moravia Street). After her first husband, Edward, died in 1898, she bought Hans P. Jacobs's home, added a wide porch and a stonewall, and named it Stonewall Cottage (on the right). She opened it to tourists in 1899.

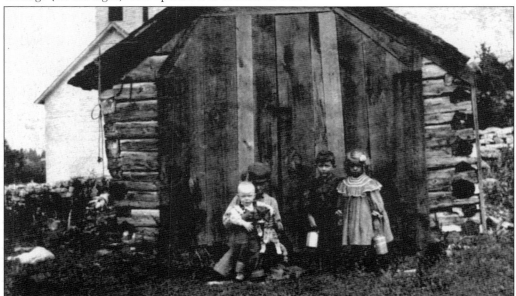

In front of this outbuilding on the Stonewall Cottage property, sits Everett (Tillie and Edward's son) at age 11, holding Warren Davis Sr. and a cat. The photograph appears on a 1901 postcard sent to May Davis, who was married to R. C. Davis. R. C. was a purser and general passenger agent on the Goodrich line. His family stayed at the Anderson Hotel. The other two children are probably hotel guests. (Courtesy of Bob Davis.)

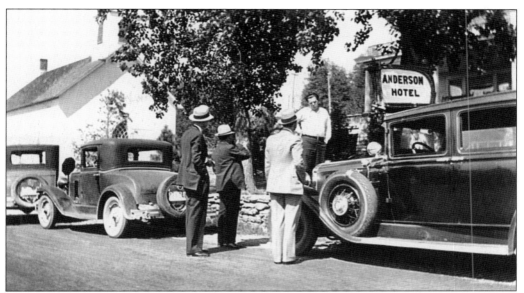

Everett Valentine is talking with arriving guests at the Anderson Hotel, probably in the mid-1920s or early 1930s. The Lutheran church, across County Highway Q, is seen on the left. Everett died in 1952. His wife, Kittie, and children, Eddie and Corrine, carried on for another 20 years, selling to Paul and Kay Wilson in 1972. The Wilsons sold in 1978, and the hotel was converted into condominiums.

This photograph was taken at a dress-up party at the Anderson Hotel on August 10, 1949. Included are hotel guests as well as villagers. Munda Anderson (standing far right) is wearing the dress she made at age 16 and wore again at age 80. It is now on display at the Anderson Store, where she worked with her sister Lizzie and her brother Adolph.

After ship's cook Peder Knudson married Hulda Seiler, he began baking bread for summer residents who had cottages at the north end of Ephraim. At the urging of his customers, he built a dining room onto his house in 1905. He continued building, eventually adding eight cottages. The main lodge at Knudson House is shown here during the 1930s. The hotel was widely known for its authentic Scandinavian smorgasbords.

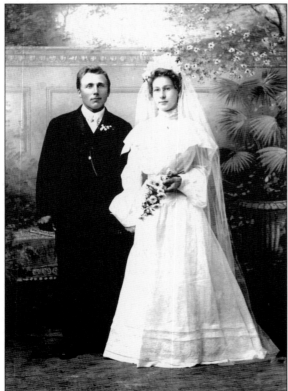

Peder and Hulda were married in 1903. Hulda's dress was entirely handmade, and Peder delivered their wedding invitations on horseback. The couple's daughter Malinda, or Mally, was born in 1907. When Hulda died in 1920, Peder sold the Knudson House and became a caretaker for Fordel Hogenson at Evergreen Beach Hotel. Peder married Fordel's daughter Dena in 1921, bought back Knudson House, and built Dena a new house across the street.

Two cousins about two years old are seen here. Mally Knudson (Mayhew), daughter of Peder and Hulda, is on the left; Ruby Knudson, daughter of Jack and Ida, is on the right. Tragically, Ruby died at age eight. Mally married Tom Mayhew, and they bought the Knudson House in 1940. In 1969, Tom and Mally sold to Jim and Marty Jacobs, who converted the lodge and cottages to condominiums.

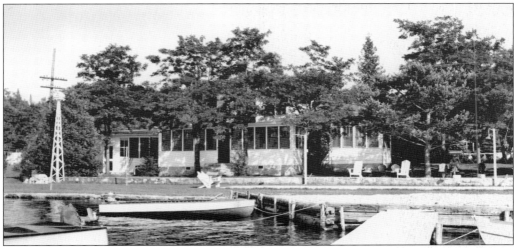

Shorewood Hotel and Cottages was established by Jack and Ida Knudson in the late 1920s. They enlarged a log cabin on the beach, adding a dining room, five bedrooms, and a bath. There were also six cottages across the highway. In 1948, Charles Sumner Larsen bought it, adding four more cottages. Charles and Marcia Larsen took over upon Charles Sumner's death in 1950. The lodge is now a private home, and the cottages are shops.

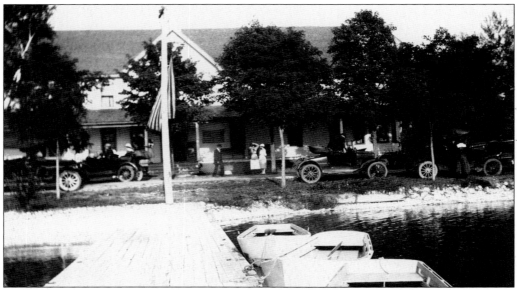

In 1901, L. E. Olson built a hotel at what is now 10040 Water Street. In 1906, third owners Matilda, or Tilla, and Elias Helgeson renamed it Edgewater Lodge. It was next door to Tilla's uncle James's Hanson's General Store. In 1965, Alvin and Janet Krause bought it and transformed it into motel units, and in 1977 they connected it to Lang's Resort (which had previously been Hanson's General Store).

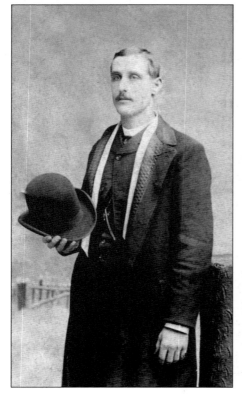

The family of Elias (shown) and Tilla operated Edgewater Lodge until 1961. Elias was a fisherman who had worked in James Hanson's store for 20 years. Besides helping run the hotel, he served as Ephraim's treasurer and tax collector. Elias and Tilla had eight children, five of whom helped their mother run the hotel after Elias's death in 1923 and continued to do so after Tilla's death in 1954.

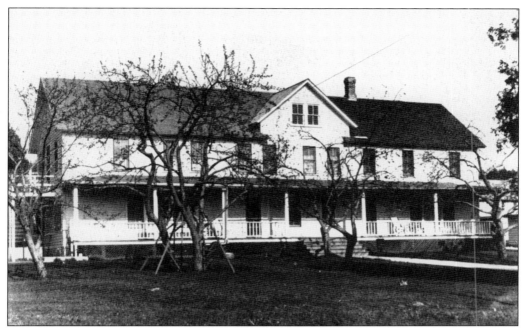

Charles and Christina Jarman and their daughter Augusta lived near Anderson Dock, where the Goodrich steamers arrived with passengers looking for places to stay. Pine Grove Hotel began in 1905 when a visitor knocked on the Jarmans' door, and they invited her to board with them. By 1927, the building had been developed to the extent shown here, with a dining room, indoor toilets, and cottages behind. (Courtesy of Jane Olson.)

Augusta married Alfred Olson in 1909. Here their son Lloyd is showing off his catch near Pine Grove Hotel's water tower around 1930. Lloyd married Marion Smejkal in 1937, and she became Pine Grove Hotel's pastry chef. Their sons were Howard and Richard. Howard married Jane Cole, and in 1968, they took over Pine Grove Hotel. In 1972, it was sold to Tony and Elaine Wilson and torn down, and a modern motel was erected. (Courtesy of Jane Olson.)

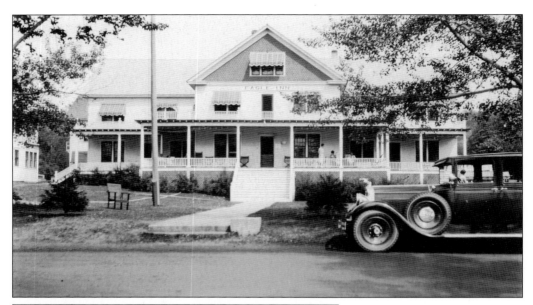

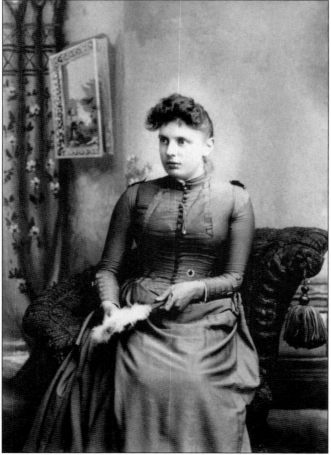

Eagle Inn (above) was a project of Eugenia (Genia) Smith (left), daughter of prominent storekeeper Jacob Smith. After she married B. D. Thorp, she decided to built a first-class hotel on property next to her family's homestead. B. D. was an engineer, helping construct the Sturgeon Bay Ship Canal, so Genia ran the inn and supervised the dining room with impeccable taste and high standards. In 1944, Eagle Inn was turned over to son Ivan and his wife, Bertha. Their other son Glen and his wife Marion had two children, Bert and Betty, who grew up helping out at Eagle Inn for years. Bert and his wife, Gloria, with sister Betty Thorp Overbeck as general manager, operated the property until 1973, when they razed the old inn and built a motel. In 1979, the motel was moved by barge to Fish Creek.

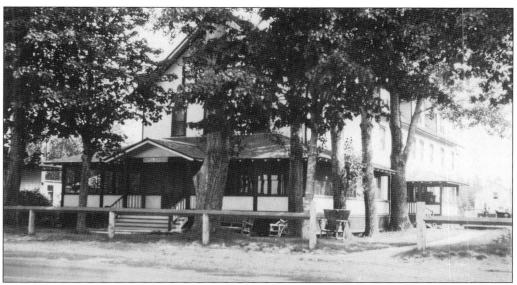

In 1926, Jimmy Woodruff and his wife, Christenza, opened Ephraim's last hotel, Lakeshore Resort (above). After one season, it fell into bankruptcy. Lester Eatough acquired it and renamed it Hotel Ephraim. His wife, Elsie, and some of her siblings managed it. Although the accommodations were rustic and the plumbing primitive, it was one of the few Ephraim hotels with a sand beach. Over time, Lester expanded and improved the hotel and added cottages (below). The oldest cottage was the one that Thomas Goodletson had built on Horseshoe Island prior to 1857 and later moved over on the ice. In 1945, Ted Hoeppner married Lester and Elsie's daughter Jeannette, and in 1964, the Hoeppners took over ownership. The first condominiums in Ephraim were constructed in the back of the property in 1970, and in 1975, Hotel Ephraim was torn down.

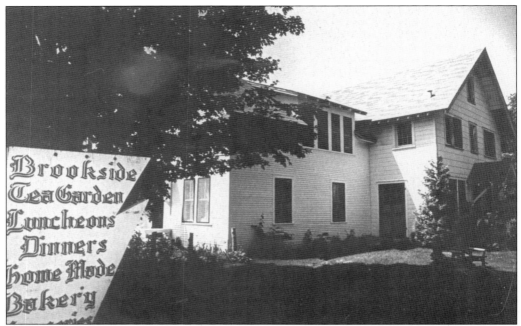

In 1920, George Larson built a tearoom beside a brook for his daughter Olive Gunhild Larson—known to all as Hilda. She named it Brookside Tea Garden. Her father later added a dining room to protect guests from the brook's ferocious mosquitoes. Hilda served three delicious meals a day and ran a store that featured her famous baked goods as well as some groceries.

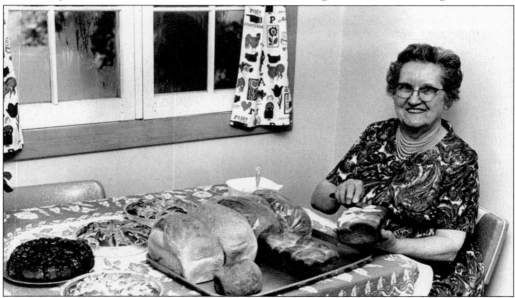

Hilda married Al Paschke, owner of a drilling and blasting company. Their three children, Mary Lou, Peg, and Wayne, all helped in their mother's business, as did Hilda's mother, "Grandma" Mary Larson, and friend Emma Hanson. Hilda died in 1975 at age 83. Daughter Peg and granddaughter Liz took over until 1977, when Brookside Tea Garden was sold and replaced by Winding Brook Condominiums.

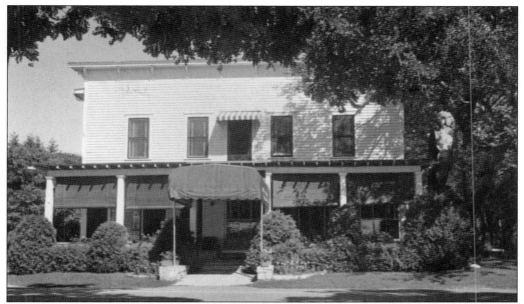

Peter Peterson built his store sometime before 1861 and sold it to his adopted son James Hanson in 1882. For the next 37 years, it was a general store and the Ephraim post office, with 10 rooms to rent upstairs. B. D. Thorp, owner of Eagle Inn, owned it from 1919 to 1939. It became Lang's Resort in 1942, with a green canopy over the front entryway as its trademark.

A happy guest at Lang's Resort Dining Room is being served by Josie and Elmer's daughter, Bernice Lang (later Koehler), on the left, and Carol (later to be the wife of Robert Lang, brother of Bernice), on the right. The Lang family was deservedly proud of its dining room. The Old Post Office Restaurant, at 10040 Water Street, now occupies this building.

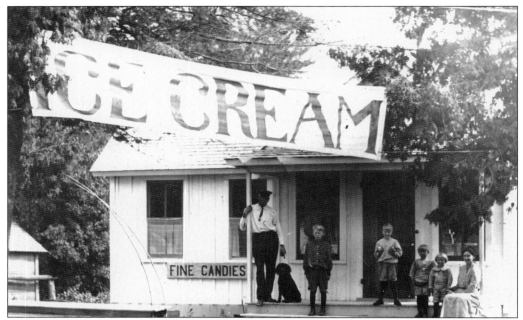

The Wilson family is shown on the steps of the Oneson fish shanty, where the first Wilson's Ice Cream Parlor began. They are, from left to right, owner Oscar (died in 1948); oldest son Harold (1900–1987); Orvis (1903–1965), who operated Wilson's for many years after his parents' death; Carl (1905–1982); youngest son Hollis (1906–); and mother Mattie, sister of Tillie Anderson.

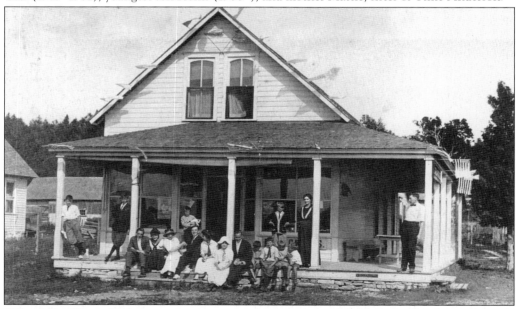

Wilson's Ice Cream Parlor moved to its present location around 1906. Peder Knudson, carpenter and owner of the Knudson House, helped Oscar build the new structure. Originally there was only one room upstairs, but during the summer the family rented their home on the adjacent lot to visitors while they stayed above the store, so they divided it into two rooms and added another window.

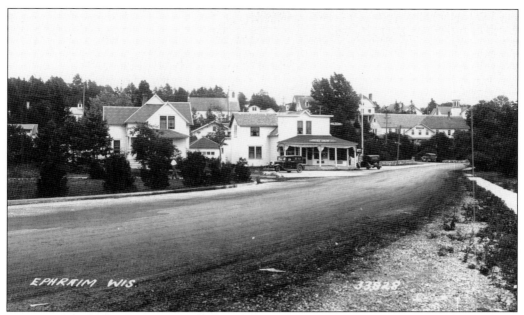

This photograph shows that trees have grown, Water Street has been widened and paved, and a sidewalk has appeared. Wilson's Ice Cream Parlor now has a flat front across its second story, an addition in the rear, and a garage to accommodate automobiles, which are becoming more common.

The youngest Wilson brother, Hollis, did not enjoy waiting on customers as much as his three brothers, but he did do much of the physical labor, including cutting ice from the bay in winter and tending it in the icehouse. He was a high school arts and crafts teacher and then was in the construction business for 30 years. His wife, Beatrice (Petie), is at the front in this picture.

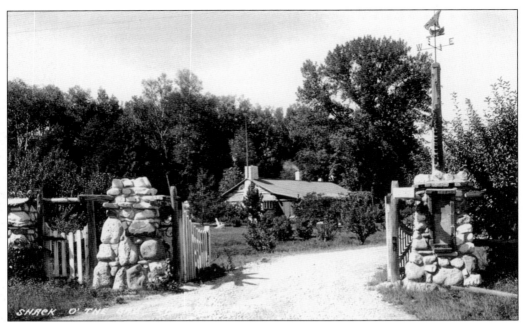

After her husband, Chicago doctor Peter Clemenson, died in 1932, Bodille (Lou) Clemenson married his chauffeur, Thorvald Hansen. Around 1940, Thorvald and Lou moved into the Clemensons' beautiful summer home, "Shack O' the Bay." Thorvald winterized the house and built eight cottages, which he rented to the same families for the entire summer season. He later added a motel unit.

The Alfon Jensen cottages were established by the Jensen family who lived on the corner of Highway 42 and Maple Grove Road. In the winter of 1944, Alfon and his brother Emery died after breaking through the ice near Nicolet point. The cottages are typical of the independent small cottage rentals; they were unassociated with resorts, established by families, and popular from the 1940s through the 1980s throughout northern Door County.

Six

CULTURE AND RECREATION

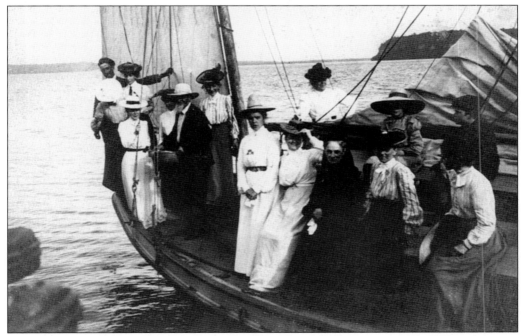

The beauty of woods and water is the backdrop and inspiration for a majority of Door County's pastimes, summer or winter. Swimming, boating, fishing, and many other pastimes eased the difficulty of pioneer life in early Ephraim. The natural beauty has inspired the creation of works of art and the establishment of artistic endeavors spanning a wide variety of music, performance, and visual media. Over the years, camaraderie, fun, appreciation, and enjoyment have enriched the lives of residents and visitors alike.

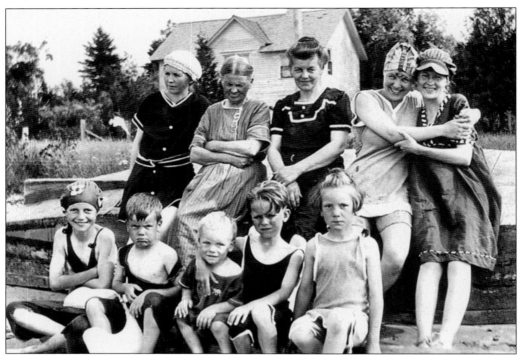

Swimming has been one of the most accessible and enduring of Ephraim's summer pastimes. Here several generations of the Goodlett (formerly Goodletson) family enjoy a beautiful summer day at the beach near their home. "Grandma" Hedvig Goodlett is the second lady from the left in the housedress; everyone else looks ready for another dip in the cool waters of the bay.

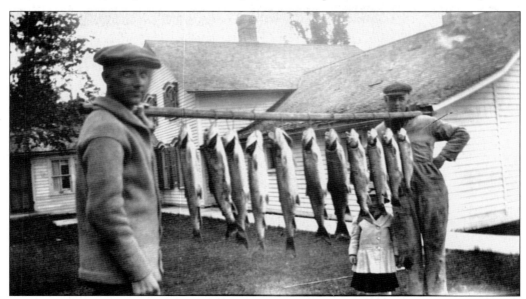

While fishing was the lifeblood for many commercial fishermen, it was also a favorite way of relaxing and enjoying the water. Here are two happy fishermen in front of the Anderson family home with a string of 11 sizeable fish. Notice the popular flat caps the men are sporting.

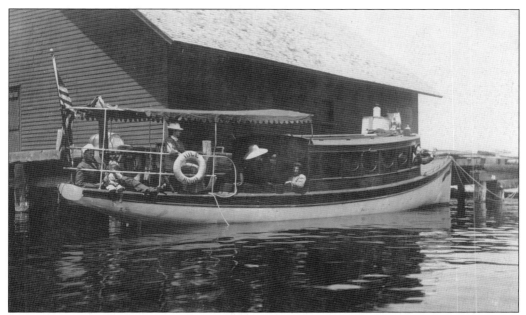

The charming pleasure boat docked at the Anderson Dock belonged to Engelbert F. Folda. It was a familiar sight plying its way across Eagle Harbor between the Folda estate on Horseshoe Island and Anderson Dock. This cruising boat was often enjoyed by the Foldas' many visitors from their home in Omaha.

With the advent of the automobile, folks with cars tended to drive directly to a destination (perhaps the next village) rather than go for an aimless ramble. This was not surprising, because roads were rough, and tires were unreliable. After 1920, when county roads improved, it became popular to ride through Peninsula State Park and other scenic areas of the county to enjoy the beauty and perhaps a picnic.

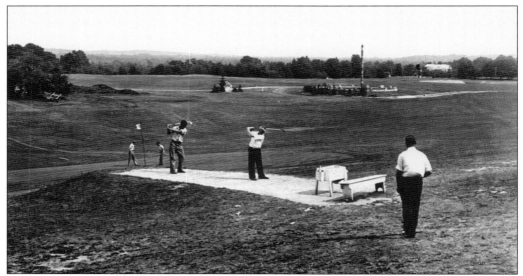

The opening of Peninsula State Park created the opportunity to meet friends for a game of golf on the new course. In the background is the carved memorial pole, erected to honor the Potawatomi Native Americans, which was dedicated in 1927. Golf at the park has continued to grow in popularity. The course is now operated by the Peninsula Golf Association.

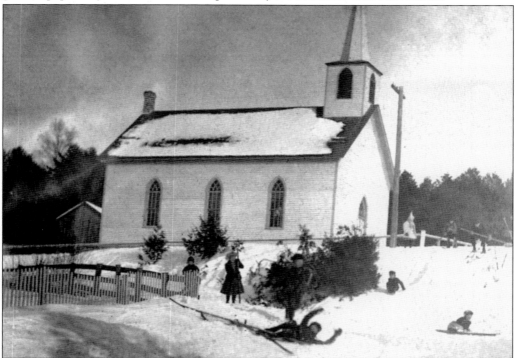

Fun was not restricted to the summer season, since snow and ice provided a new set of opportunities for both outdoor and indoor recreation. Bethany Lutheran Church provides the backdrop for these children sliding and skiing down old County Highway Q, probably during lunchtime or after school, around 1920. Ice-skating on Eagle Harbor was a popular pastime as well.

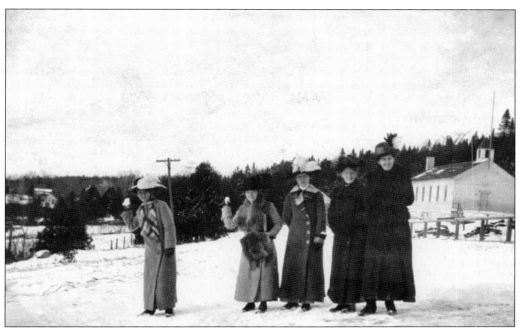

Children were not the only ones who had fun outside in the winter. Here Grace, Pearl, and Lilly Helgeson, Julia Olson, and a friend pose with snowballs on Moravia Street, about 1915, probably on their way to church judging from their dress coats and hats. Walking, whether winter or summer, was a way of life, as well as an opportunity to casually socialize and visit with friends.

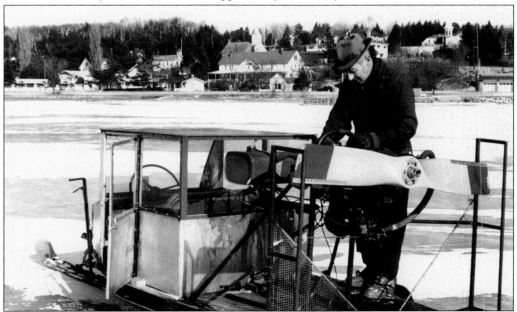

While early residents enjoyed sail sleighs, a few villagers created motor-powered sleighs as a way to enjoy the ice when it froze thick and smooth. Here Bill Sohns is working on his "sail plane" far out on the ice of Eagle Harbor. The large propeller was capable of moving the craft across the ice at good speed. The village is visible in the background. (Courtesy of Sohns family.)

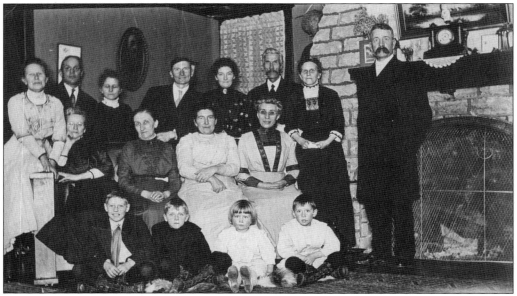

Indoor get-togethers were popular, in both winter and summer. These friends are gathered at the home of Dr. Gustav Egeland. They are, from left to right, (first row) Orvis Wilson, Carl Wilson, Henry Anderson, and Hollis Wilson; (second row) Lizzie Anderson, Anna Petterson, Tillie Valentine, and Toneta Hogenson, (third row) Elvira Anderson Egeland, Clarence Smith, Munda Anderson, Oscar Wilson, Mattie Wilson, Fordel Hogenson, Olive Anderson, and Rev. Anders Petterson.

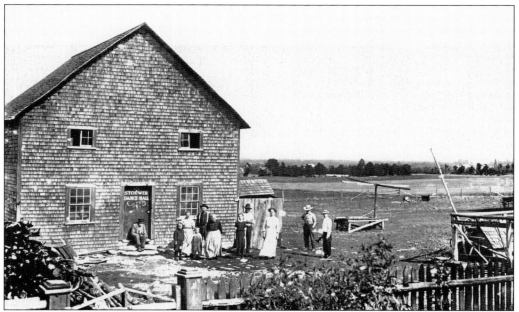

Farmers of the German settlement were often entertained at the Stoewer (Staver) family granary, which doubled as a dance hall, around 1910. Although it was difficult to travel long distances to enjoy entertainment, in later years people came from all over the county to watch silent movies at the Anderson Dock, while sitting on hay bales. (Courtesy of Augusta Brungraber.)

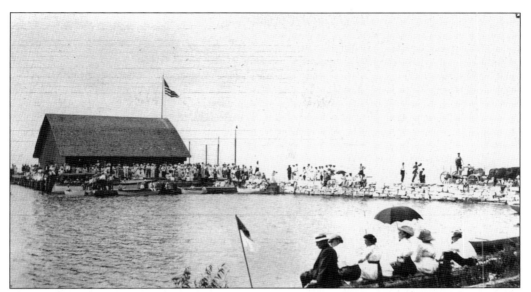

One of the most popular and enduring of the early summer activities was—and continues to be— the Ephraim Yacht Club's annual regatta. Begun in 1906, it is the oldest continuously held regatta on the Great Lakes. This 1913 image shows a crowd on the dock watching the many races and activities, while well-dressed ladies sit on the shore, protecting their complexions with parasols.

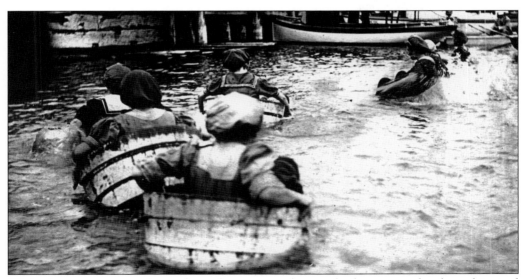

Washtub races were popular at the early regattas, when washtubs were made of wood instead of metal. The girl's race, from around 1914, can be seen here. Hollis Wilson, winner of an early boy's race, claimed that the key to winning the washtub race was to splash more water into a competitor's tub than he could splash into yours, and the last person swamped won the race.

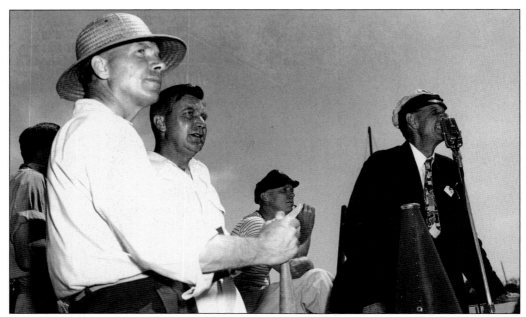

Three Ephraim Yacht Club commodores appear in this picture, around 1946. Accompanied by Dan DeWitt (left), they are, from left to right, Ray Nelson, Warren Davis Sr., and Malcolm Vail. The commodore acts as president of the organization. There is also a vice commodore, who follows the current commodore into office. Other members are responsible for social events and for the lessons on sailing and water safety that have become the trademark of the Ephraim Yacht Club.

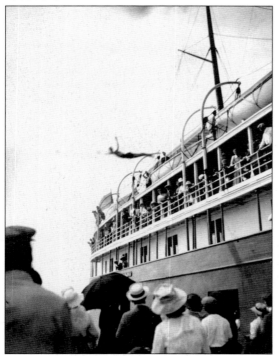

The Hardin boys (summer residents) became famous for their antics, driving Capt. Daniel McGarity of the steamship *Carolina* to distraction by sneaking on the ship and diving off into the water—to the entertainment of the passengers and the ire of the captain. The boys sometimes disguised themselves in their mother's clothes and boarded the boat at different ports to circumvent the captain's security measures. (Courtesy of Hardin family.)

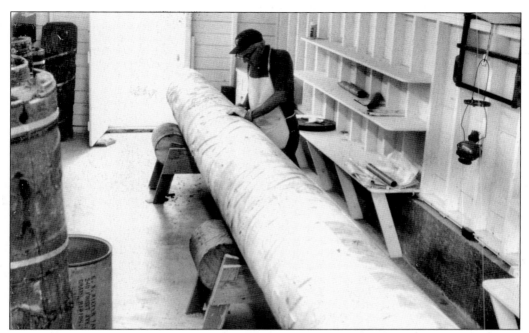

Adlai Hardin (one of the Hardin boys) grew up to become a well-known sculptor. In 1968, he volunteered to carve a replacement for the deteriorating memorial pole in Peninsula State Park. He worked in the east wing of the Anderson Store (now the Anderson Store Museum tool room), where the huge pole lay on wooden horses. Today the pole still stands on the park golf course, honoring the Potawatomi. (Courtesy of Hardin family.)

The arts had an early start in the Ephraim area. The first of the local artists is considered to be Vida Weborg, daughter of immigrant Peter Weborg, whose farm stood in what is now Peninsula State Park. She painted and drew many ink and pencil sketches of area landscapes. To earn money in the summers, she painted oil landscapes on rocks and sold them at the Anderson Store.

Doris Heise Miller (right) established one of the first jewelry and gift shops in Ephraim in 1932. She rented a small log cabin, part of the Shorewood Hotel and Cottages, from Jack Knudson. She later moved her Cabin Craft shop across the street, where she specialized in decorative items and her own handmade silver initial jewelry. In 1966, she stopped making jewelry, but the shop continued in operation until 1972.

Francis Hardy first came to spend summers in Ephraim in 1930. A businessman, he became an adept watercolorist and was a charter member of the Peninsula Arts Association. With his contributions, in 1961, the Anderson Dock warehouse was fitted with lighting to serve as a summer art gallery in 1961. In appreciation, the Hardy Gallery was named after him and remains a popular summer attraction.

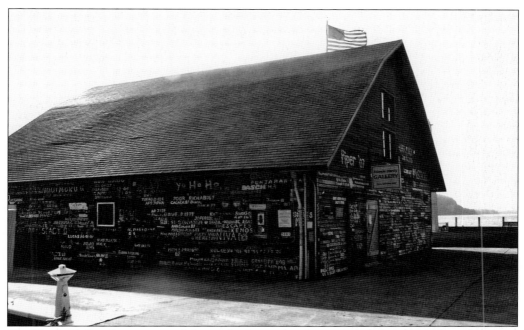

The Hardy Gallery has supported the work of many local artists, including enamelist and author Leon Statham, nationally known portrait artist Lester Bentley, and longtime gallery owner and miniaturist Charlie Lyons, among many others. Among the early artists in Ephraim were Maybelle Holland, Frieda Brenner, and Frances Moss.

Madeline Tripp Tourtelot was central to the development of the arts in Door County. In 1934, she came to attend classes at the newly founded Fish Creek Art Colony. She returned to Fish Creek in 1964 and established the Harbor School of Art, now the Peninsula Art School, which has educated thousands of both serious and novice art students. For a number of years, she maintained a home in Ephraim.

The Peninsula Music Festival, brainchild of Lorenz Heise, Kay Wilson, and conductor Thor Johnson, began in 1953. Shortly after its establishment, a volunteer group of women was formed to support the festival. Shown here, from left to right, are (first row) Kay Wilson and Dorothy Evans; (second row) EllaMae Heise, Petie Wilson, Marcia Larsen, Rosa Katz, and Mrs. Roy Hanson. (Courtesy of Peninsula Music Festival.)

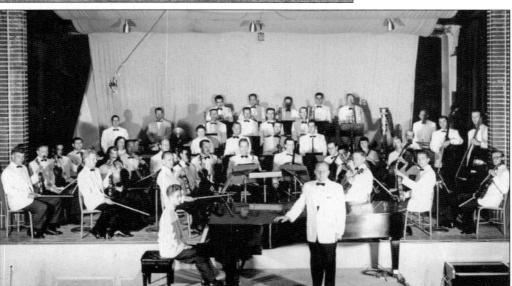

For many years, the Peninsula Music Festival orchestra played in the Gibraltar High School gym, where the Ephraim Men's Club rented out seat cushions for the hard folding chairs. Lack of air conditioning in August challenged even the most ardent music lovers, until a modern auditorium was built adjacent to the school. The Peninsula Music Festival is a first-class professional orchestra that has always maintained a stellar reputation and an avid following.

Seven

PENINSULA STATE PARK

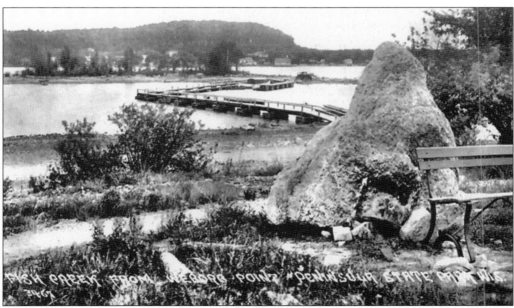

In 1907, the state legislature began considering the possibility of developing a state park system. A wealthy U.S. senator from nearby Marinette offered the state $25,000 toward acquisition of acreage in Door County. With that incentive, the legislature appropriated an additional $75,000, and the headland between Fish Creek and Ephraim was chosen. Shortly afterward, applying laws of eminent domain, the state began pursuing the purchase of land and homesteads of the 200 residents (35 families) of the newly designated area. Using negotiations and extended leases, title to the 3,700 acres was eventually acquired. Albert E. (known as Mr. D) Doolittle was hired as the first park superintendent.

Hjalmar Holand, who had come to Ephraim as a young man, owned a lovely small farm in the area being sought for the state park. He was vociferously opposed to selling his property to the state, but he eventually gave in and built a house across the highway from the park. Holand founded the Door County Historical Society, wrote numerous books on local and Norse history, and was responsible for Ephraim's incorporation in 1919.

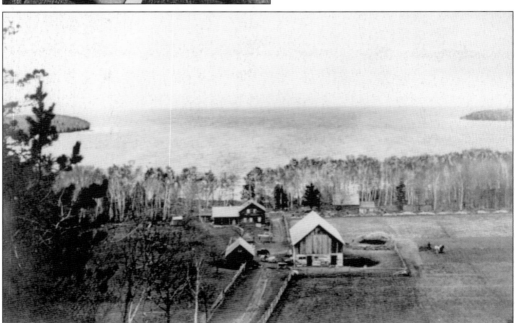

This is believed to be the farmstead of Ole Larsen and his family, located near Nicolet Bay in the present Peninsula State Park. Previously Larsen had lived on Horseshoe Island (visible a short distance off shore, on the right), where he was a logger. When he had logged all the timber off the island, he moved to the mainland.

In 1913, Peninsula State Park's first superintendent, Albert E. Doolittle, moved to the park with his wife and seven children. He was a bold decision maker with a clear vision of his plan for the park. With fierce determination, he developed the park into what he intended it to be—one of the nation's natural treasures. Doolittle retired in 1943 after 30 years of service. (Courtesy of Carol Hackett.)

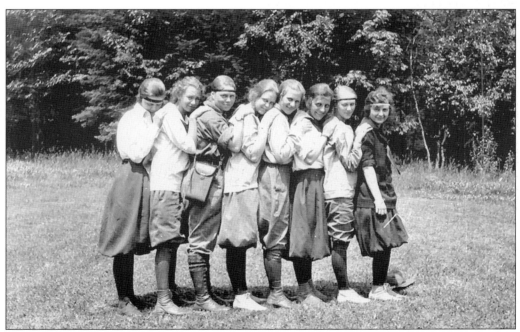

From 1916 to 1948, Peninsula State Park was the site of Camp Meenahga for girls. Dressed in bloomers and middy blouses, the girls spent their days in nature study, art classes, dancing, swimming, canoeing, drama, and horseback riding. They slept in tents on platforms and ate in a large cafeteria, making an occasional foray into Ephraim for a Wilson's ice cream cone.

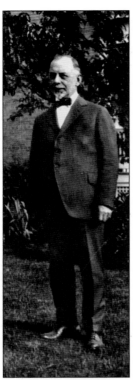

Englebert F. Folda, a prominent banker from Nebraska, owned Horseshoe Island, which is about a half-mile off the shore of Peninsula State Park. On it, he and his family built a lodge that they named "Engelmar," in which the family entertained grandly during the summer months. The girls from Camp Meenahga received a coveted invitation once each summer to visit for tea and sweets with Alma Folda, Engelbert F. Folda's wife.

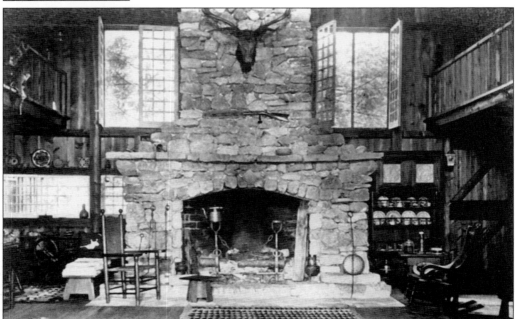

This view of the interior of Engelmar, the Foldas' main lodge, illustrates the scale of the building. The great room was 35 feet high, and one could stand inside the fireplace. The failure of Folda's chain of banks during the Great Depression resulted in the family's financial collapse, and the property became part of Peninsula State Park. Nothing remains of Foldas' compound of buildings.

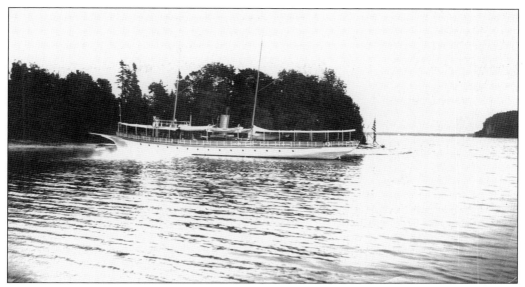

The Folda family frequently hosted similarly affluent guests who brought their large yachts to the small bay that defines Horseshoe Island. The Foldas had their own smaller yacht, which they used to commute to and from Ephraim. Shown in the background is Eagle Bluff, part of Peninsula State Park, which was, at one time, owned by Door County historian Hjalmar R. Holand.

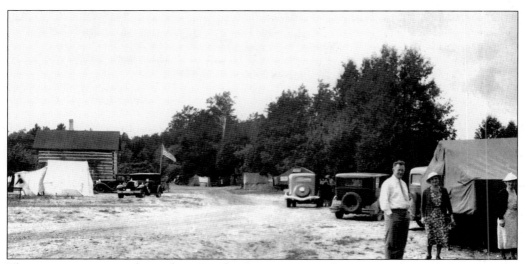

These campsites were located at Nicolet Bay in Peninsula State Park in the 1920s. The earliest campers pitched simple tents, but as campers began to stay for the entire summer, park superintendent Albert E. Doolittle permitted campers to erect simple shanties. This practice gave Nicolet Bay its informal name of "Shanty Bay."

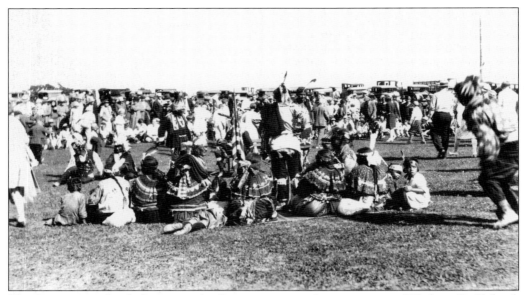

The first memorial pole honoring the Potawatomi was the inspiration of Hjalmar R. Holand. It was carved by C. M. Lasaar and dedicated on August 14, 1927, with several thousand in attendance, including 32 tribal members. The pole consisted of 12 carved panels, reflecting the Potawatomi's religion and life. It is visible to the right as a backdrop to this funeral of Khaquados, chief of the Potawatomi, held May 30, 1931.

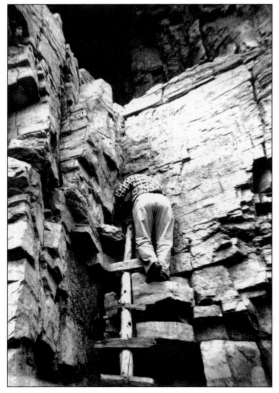

A climber mounts the sheer face of Eagle Bluff. He is shown attempting to reach a sea cave formed by pounding waves of water and wind eons past, when the lake level was much higher. Along the shoreline below, but well to the south, a temporary settlement of workers struggled to quarry limestone. The enterprise lasted only a few years before being abandoned in the mid-1800s.

During the Great Depression, the Civilian Conservation Corps undertook many construction projects in the park. One of the most popular was a ski jump, which opened in 1937. It was found to be unsafe and was replaced by superintendent Albert E. Doolittle's crew a year later. The new jump's 100-foot take-off was so long that a park road ran under it.

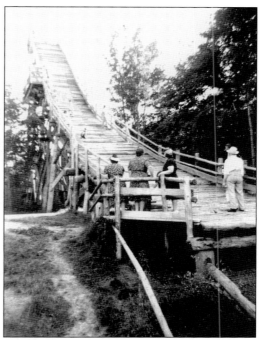

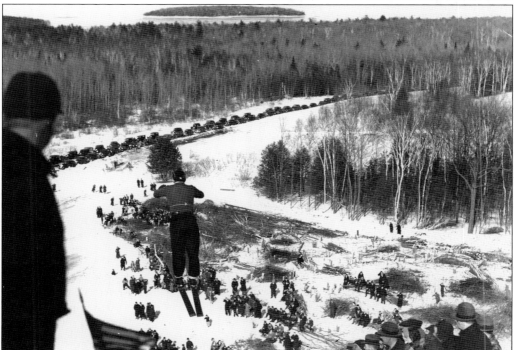

The great popularity of the park's ski jumping contests is illustrated by the crowds of several thousand that came to participate or watch. The daring competitions attracted skiers from far away, as well as local talent. By the late 1940s, safety concerns again emerged, and the jump was torn down. Horseshoe Island is visible in the background.

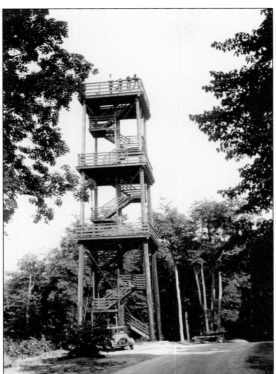

Providing campers with great viewing sites was important to superintendent Albert E. Doolittle and, over time, several towers were erected, starting as early as 1915. The current and tallest is Eagle Tower—75 feet high with viewing platforms at different levels. The top platform is about 240 feet above the waters of Green Bay. Each year, thousands of visitors are attracted to climb it and enjoy its spectacular views.

Eagle Terrace is one of the most visited sites in Peninsula State Park. Originally the site of a quarry, it has been a gathering spot for picnics over the years. Early in the park's history, it was a favorite spot for adventurous youngsters to climb down the face of the bluff or for older folks to descend to the bottom via a rickety wooden ladder.

Eight
FACES AND FAMILIES

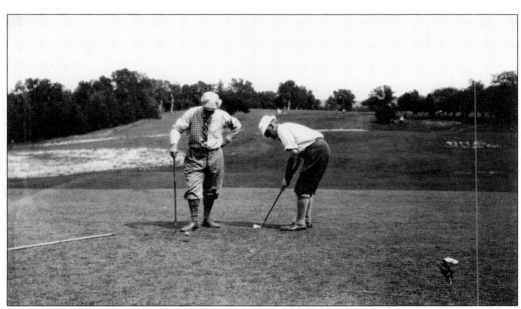

The scenic beauty of surrounding bluffs was a growing attraction to many around 1900. Families new to the area quickly became enamored of the healthful fresh air and serene beauty. There was a growing interest in health-oriented diets, fresh air benefits, and exercise (called by some the "Rustification Movement"). The summer months in Ephraim were a time for the special refreshment that the wilderness offered. In the image above, George Norton Jr. (left) enjoys the fresh air and a friendly game of golf at the Peninsula Golf Course.

Hans Nelson, son of Carl Nelson, married Addie Smith, daughter of Jacob Smith and sister of Eugenia Smith Thorp. Hans was a carpenter and lived for a time in the original 1850s Nelson homestead, although he also lived in Sturgeon Bay and Milwaukee at various times. He loved fishing and is shown here on his boat in the Ephraim harbor.

Emma Hanson, daughter of Ole and Mary Hanson, attended Bethany Lutheran Church from her birth in 1894 until her death in 1988. Emma started school at age 10, walking three miles each way. At age 16, she was sent to Chicago to work and became her family's main breadwinner. After 24 years she returned to Door County, where she worked on the family's farm and baked at Brookside Tea Garden.

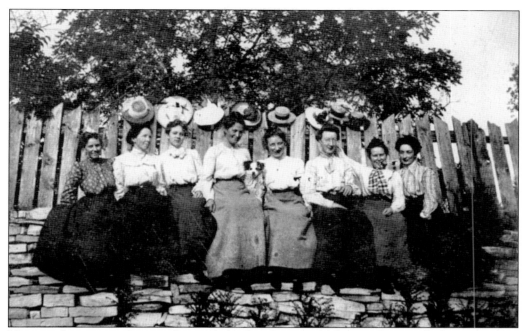

Here is a charming gathering of young ladies lined up on a high stone fence with their saucy hats in the background. They are, from left to right, Olive Anderson, Laura McSweeney (long time school teacher), Agnes Anderson, Julia Olson, Cordelia Anderson Hogenson, Dena Hogenson Knudson, Elvira Anderson Egeland, and unidentified. Most of these young ladies worked hard at their resorts or businesses during the summer, so this was a welcome respite.

Friends, family, and former sailors are seen here around 1890. Seated is Ole Thompson; standing are, from left to right, Peder Knudson; Peder's brother-in-law, Herman Hogenson; and Peder's brother, chiropractor Dr. Jack Knudson. The men are wearing ribbon badges that identify them as members of the Lake Seamen's Union of Milwaukee and were evidently attending a convention in that city.

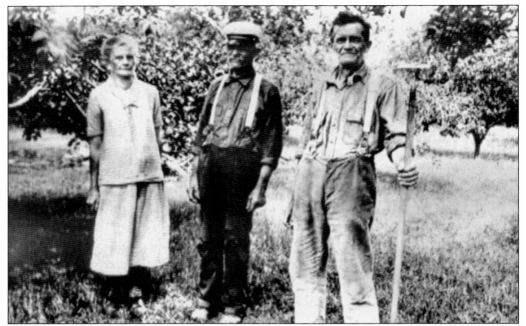

Charlotte, Anton, and Henry Amundson are pictured on their 69-acre Coral Hill farm. Anton (center) is believed to be the second white child born in Ephraim. He and his three brothers made orchards and fishing their livelihood. Anton married Moravian Rev. Anders Petterson's sister Anna in 1888.

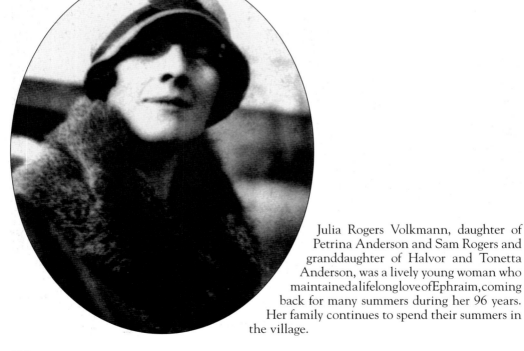

Julia Rogers Volkmann, daughter of Petrina Anderson and Sam Rogers and granddaughter of Halvor and Tonetta Anderson, was a lively young woman who maintained a lifelong love of Ephraim, coming back for many summers during her 96 years. Her family continues to spend their summers in the village.

This is the only instance during which all the Goodlett siblings were captured on film. They stood on Highway 42 following their mother Hedvig's funeral in 1936. Seen here are, from left to right, EllaMae (Heise), Wilfred, Florence (Hagman), Alice (White), Lillie (Glaser), Elmer, Hilda, Edgar, Emma (Johnson), and Edith (Hogenson). There are 25 years between the oldest and youngest Goodlett.

The marriage of EllaMae to Lorenz Heise took place in October 1935. Malinda Knudson Mayhew, daughter of Peder and Hulda Knudson, to the right of the happy couple, served as an attendant. The Heises had one child, Hedy, who lives in the Goodlett family homestead and continues her parents' contributions to the community.

Charles M. Moss, professor of Latin and Greek, arrived in Ephraim with his family as passengers on the Goodrich steamboat line in 1887. Immediately smitten with the area, they remained as summer boarders for six summers until they built "Rocky Rest" (1901), the "Hemlocks" (1912), and the "Birches" (1941). Loving to sail, he and 22 others organized the Ephraim Yacht Club in 1906, and he served as its commodore in 1910.

The Pease family cottage, shown here, is considered by some to be the first summer cottage in Ephraim. Frank Pease, a lawyer from Chicago who did legal work for the Goodrich Steamship Line, bought land in back of the Evergreen Beach Hotel in 1889 and built a cottage around 1900. Martha Luella Norton, wife of George Norton Sr., stands on the left. The woman on the right is probably Mrs. Pease.

Martha Luella, wife of George Norton Sr., is photographed enjoying some time on Anderson Dock soon after she and here husband had built a summer cottage for their family of two children, Lawrence and George. Martha died in 1921, but George and Larry maintained residences in Door County and were actively involved in support of community affairs for many years.

Anne Stevens Kirkland, adorned in her finest fashion (around 1915), is seen here. With encouragement from her brother Dr. David Stevens, she purchased property with her husband, Harry, on North Shore Road. Anne majored in music at Lawrence University in early 1900, and after her husband's premature death in 1931, she worked as a housemother at Miami College of Ohio.

Sophie Beaumont and a heron appear on a makeshift dock along the south shoreline of Ephraim. Her parasol, cap, and bloomers place the time frame at about 1900. Her father owned the Beaumont Hotel in Green Bay, and her grandfather Dr. William Beaumont was famous for researching digestive processes by observing a persistent open bullet hole in the stomach of a Native American subject.

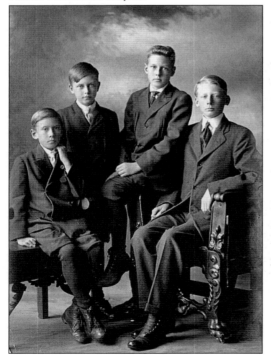

The sons of Oscar and Mattie Wilson, seen here around 1914, are, from left to right, Hollis, who taught in Illinois before working in cement contracting; Orvis, who left Harris Bank and Trust Company in Chicago to run Wilson's Ice Cream Parlor upon their mother Mattie's death; Carl, who spent 43 years with Allis Chalmers in Milwaukee, before retiring to Ephraim; and Harold, who handled insurance and real estate in Ephraim while banding birds for the U.S. Wildlife Service.

One of many recorded Wilson family gatherings is seen here, this one around 1945, and those pictured include, clockwise from left to right, "Petie" (Mrs. Hollis) and daughter Holly, Hollis, father Oscar (affectionately known as "Uncle Oc" by friends and family), Carl and daughter Alicia, Verna (Mrs. Harold) and daughter Mary.

Charles Sumner Larsen (1885–1950) and Amy Mae Larsen (1882–1958), with their children Virginia (Renner) and Charles Jr., enjoyed camping on the lawn of their friend from Lawrence University, Dr. David Stevens, when they could not find a site in Peninsula Park (around 1925). The Larsens lived in Green Bay while Charles worked for his family's business, the Larsen Canning Company.

Dr. Henry Anderson, son of Adolph and Tillie, and his soon-to-be wife, Irene, are pictured here in front of the Anderson Hotel on the occasion of their engagement in 1937. Henry's older half-brother Everett Valentine and his wife, Kittie, operated the hotel in Ephraim while Henry pursued his medical career, coming back to summer in Ephraim with Irene and their three children.

James Spofford Reeve, fondly known as Dr. Jamie, is shown on his property, which then extended from Orchard Road to the bay below. His distinguished medical career included service as an army surgeon upon graduation from Harvard Medical School. He later practiced in Appleton, where he delivered Ruth Davis (Mrs. David Stevens) and served as the college doctor at Lawrence University (then Lawrence College.).

Ralph Horween practiced law in Chicago and became part of the Ephraim summer community in the late 1930s. He was a running back for Harvard in the 1920 Rose Bowl, and in 1996 he became the first former NFL player to turn 100 years old. He was instrumental in establishing the Ephraim Foundation by doing the legal work required to establish the organization.

Spencer (Spenny) Gould and Elizabeth (Libby) Tatman Gould board the ship *Cornia* in 1951. Libby was hooked on Ephraim after serving as a counselor at Camp Meenahga during the summer of 1925. She enthusiastically returned with her family and new husband the following year, her father and husband later purchased property. Libby organized the Anderson Store into the Ephraim Foundation's second museum in 1967.

Herman Hachmeister is pictured in front of his home with his wife, Ada. A German immigrant who settled in Chicago as a developer and realtor, he enlisted the help of his architect friend William Bernhard to build the Hachmeister home in 1926. The home, still standing, has a strong European flavor. The Hachmeisters rented cottages on their property during the Great Depression and willed the property to their daughters, Martha and Helen.

Martha Hachmeister and her soon-to-be husband Phillip (Phil) Cherry stand on the lawn of the Hachmeister home overlooking Green Bay. Phil was an engineer, and after retirement, the couple eventually became full-time residents, immersing themselves fully into village life. A painter and longtime volunteer, Martha received recognition for her generosity and years of service to the Anderson Store Museum, the Ephraim Moravian Church, the Hardy Gallery, and numerous other organizations.

Nancy Wilterding (Davis), left, is pictured with her twin siblings, Gretchen (Maring) and John, camping with their father John Wilterding Sr., a pharmacist from Algoma. In the 1930s, the family, including mother Florence, took frequent trips to Ephraim, camping in Peninsula State Park. They purchased property on South Coral Hill Road in the early 1960s. (Courtesy of Nancy Davis.)

From left to right, Bob, Warren Sr., Warnie, and Minie Davis sit along Ephraim's shore in 1928. The Ephraim Yacht Club pier is prominent in the background. It lasted one year before it was destroyed by a huge storm in 1928. Warren Sr. (along with Helen Hoeppner Sohns) organized the effort to save Ephraim's old schoolhouse in 1949, leading to the establishment of the Ephraim Foundation. His father, Robert C. Davis, was a passenger agent on the Goodrich line. (Courtesy of Bob Davis.)

Olga Dana had a strong community spirit, both when she lived in Kewaunee, Wisconsin, and later in Ephraim, where she moved permanently after her husband died. She was generous to local organizations and was the Ephraim Foundation's first female board member. In appreciation for the foundation's work and with the idea of maintaining open green space in the village, she donated the "Ephraim Green" to the foundation in 1973.

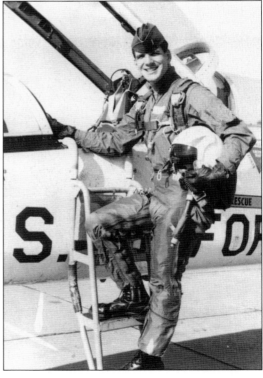

First Lt. Ellis Eugene (Gene) Helgeson Jr. (1942–1968) was the grandson of Ellis and Tilla Helgeson, owners of Edgewater Resort for 55 years. A memorial in his honor is located at the end of Anderson Dock. It commemorates Lieutenant Helgeson's heroic service in Vietnam in the U.S. Air Force 311 Air Command Squad.

Nine

FROM THE PAST TO THE FUTURE

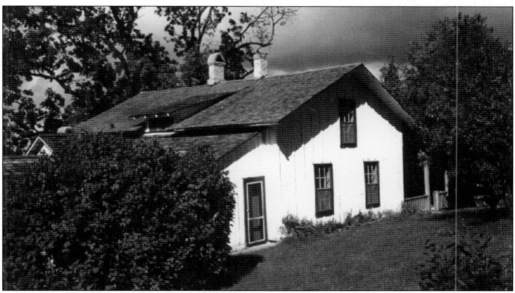

Many village organizations work to preserve Ephraim's history. The Ephraim board of trustees helps preserve Ephraim's character through zoning regulations and village ordinances. The Ephraim Business Council works to ensure that the village can grow from a business standpoint without affecting its natural beauty. The Ephraim Yacht Club takes particular interest in the beauty of Ephraim's harbor. The many arts groups in Ephraim contribute to the village's rich cultural life. And finally, the Ephraim Foundation was founded in 1949 with the express mission of working to preserve and enhance the cultural and historical aspects of the village of Ephraim. Above, the Historic Iverson House museum stands as evidence of that commitment.

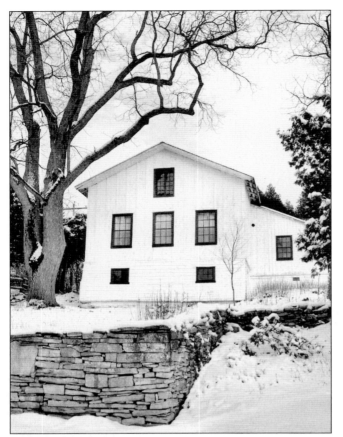

The Iverson House (left) was completed in 1854 by Rev. Andreas Iverson and members of his Moravian congregation, who were responsible for the founding of Ephraim. After Iverson left Ephraim in about 1864, the house served as a home for Moravian pastors J. J. Groenfeldt and Anders Petterson. Ultimately the home was sold to the Walker/Field family in 1912, and it remained in their possession until its purchase by the Ephraim Historical Foundation was finalized in 2004. The Iverson House is one of the oldest frame homes in Door County, with very few alterations being made in the 150-plus years it has been standing. The foundation opened the Iverson House as a museum in summer 2005, using the letters of Anna Petterson (the third minister's wife to live in the house) to guide the decoration and furnishing of the home (see below).

The Ephraim Moravian Church, founded in 1853 (right) was the first permanent Christian church in Door County and was instrumental in molding the character of the village. The Bethany Lutheran Church (below) was formed 29 years later, in 1882. Many descendants of the original Ephraim settlers still worship at one of these churches, and both have reached milestone anniversaries in the past five years—the 150th anniversary of the Ephraim Moravian Church in 2003, and the 125th of the Bethany Lutheran Church in 2007. While both congregations have seen their share of changes (Bethany Lutheran Church made the transition to a summer-only ministry in 1957), the twin white steeples of these churches stand as a testament to Ephraim's rich spiritual history and also pave the way for the religious future of the community.

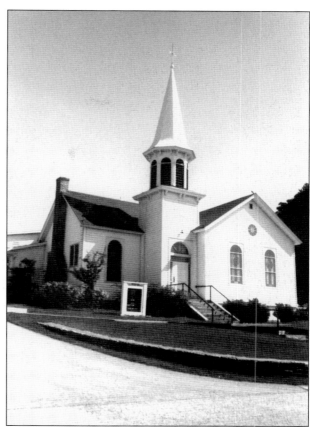

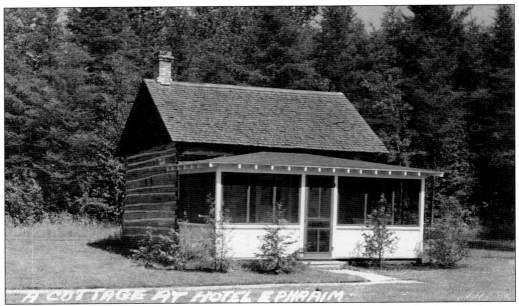

A COTTAGE AT HOTEL EPHRAIM

In 1854, Thomas Goodletson built a log cabin on Horseshoe Island to house his family of seven, and a year later, he skidded it across the ice to the mainland. Members of his family resided at this new location until 1886. Over the years, the Goodletson cabin has been put to various uses, including being used as the site of early organizational meetings for the Bethany Lutheran Church and as the "honeymoon suite" for couples staying at the Hotel Ephraim. When the hotel property was slated for condominium development, owner Ted Hoeppner offered the cabin to the Ephraim Foundation, provided it be moved off its site. The building was transported up the hill from the shore and situated adjacent to the Pioneer Schoolhouse. Today the cabin is one of the foundation's museums, where visitors can experience Ephraim's pioneer past.

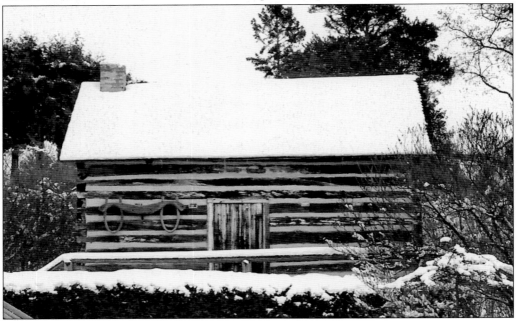

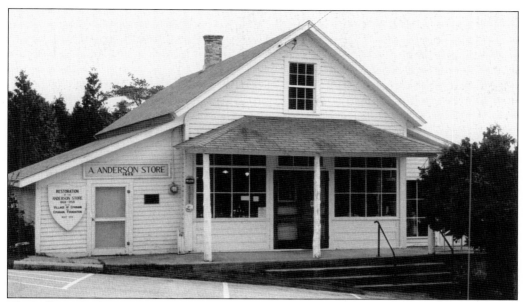

The Village of Ephraim purchased the Anderson Store in 1966 and later leased it to the Ephraim Foundation. The store, which the Anderson family ran for close to a century, was turned into a living history museum by the foundation in July 1967, complete with costumed docents and small goods for sale. It has since become one of Ephraim's most loved attractions. (Photograph by Hagedorn Studio.)

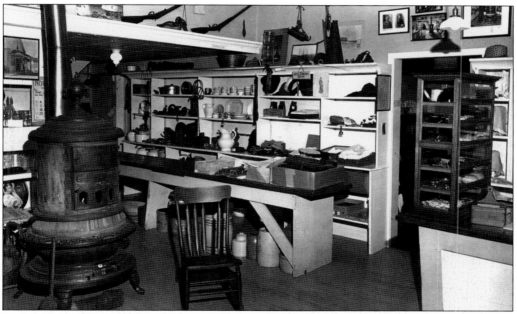

Restoration of the Anderson Store was aided greatly by the fact that the Anderson family never had a sale. Items that had gone out of style or could not be sold were carefully packed up and stored in the attic. All of the original counters and cabinets, cash register, scale, and other items were found in storage at the Anderson Barn. The store today looks nearly identical to the way it appeared in the Anderson era.

The Anderson Barn and the property on which it stood were owned by Marion Allen Haase Brophy, a friend of the Ephraim Foundation. She knew she wanted to preserve the barn, so she offered it to the foundation at a modest price, and it was subsequently purchased in 1986. There was significant damage to the barn, and many thought it could not be salvaged and made useful. With the help of a building restoration specialist, the barn was raised up off the ground, a foot of rotted bottom was cut off of the barn's perimeter, and a new foundation was poured. Once the building had undergone these improvements, the main part of the barn was converted into a museum and gallery, and an addition was added to the back of the barn to create a small archive and office for the foundation.

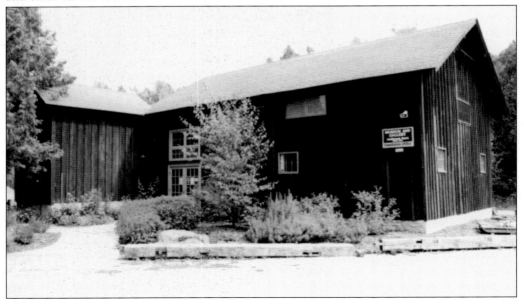

In 1998, the Ephraim Historical Foundation constructed a *svalhus* adjacent to the Anderson Barn History Center. *Svalhus* is a Norwegian term meaning "cooling house," and a *sval* is an overhang that serves to moderate the temperature inside the building. Contractors rebuilt the svalhus using logs from a dismantled cabin originally built by Peder Knudson. It later served as Doris Heise Miller's first Cabin Craft shop. Wire nails in the logs indicate that the cabin did not predate 1890 but was probably built around 1900. Today the svalhus serves as a "look in" museum of the foundation, as well as a meeting space. The old Knudson cabin is shown above, and the finished svalhus constructed from its materials is shown at right. Note the four-foot overhang on the second story.

The Ephraim Green is at the corner of Highway 42 and Spruce Lane. Olga Dana, an Ephraim summer resident, donated the green space to the Ephraim Foundation in 1973. The donation contained an agreement that promised to keep the Ephraim Green "maintained for the beautification of the village of Ephraim."

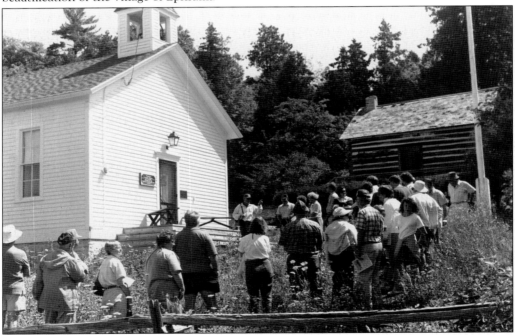

Ephraim's historical walking tours were organized by Paul Burton in 1990 and have become one of the foundation's most popular programs. This photograph shows visitors listening to a guide outside the one-room Pioneer Schoolhouse, which was built in 1880. It remained in use until vacated in 1948. The effort to preserve the schoolhouse resulted in the establishment of the Ephraim Foundation.

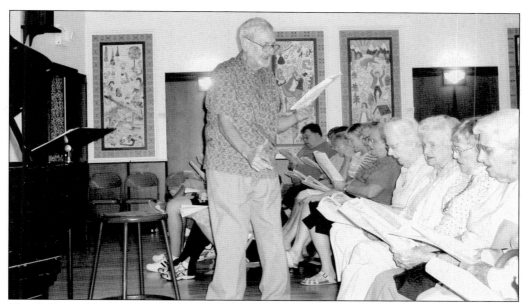

The Ephraim Family Sing-Alongs began in the 1930s when F. Melius Christiansen, famed conductor of the St. Olaf College Choir, conducted a summer choral school at the Ephraim Village Hall. The Ephraim Family Sing-Alongs were discontinued in the late 1950s, but in 1994, George Jr. and Armella Norton reintroduced them. On Sunday nights in June and July, the Ephraim Village Hall hosts standing room–only crowds who belt out hymns and old favorites.

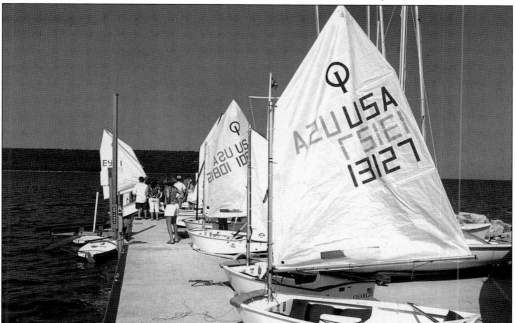

Founded in 1906, the Ephraim Yacht Club (EYC) is still going strong as one of the village's oldest organizations. The EYC is noted for the enduring support of its membership and its commitment to teaching water safety and sailing. A love for boating and Ephraim encourages the formation of lifelong friendships and summers of friendly competition at the club.

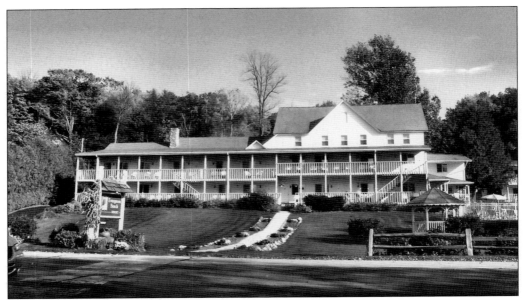

The original structure of the Evergreen Beach Hotel was built around 1900, and today it is easily identified by the colorful petunias lining its sidewalk. Like Evergreen Beach, many hotels and businesses in Ephraim operate in historic buildings. Now equipped with all of the desired amenities, these establishments maintain the perfect balance of historic preservation while understanding the needs of today's travelers.

Harborside Park is the newest addition to the village of Ephraim. The park boasts a playground and a gazebo that is ideal for summer concerts. It was the location for the first "Evenings in Ephraim" concert series in 2007. Located on the site of the original Wilson family homestead, the park provides a charming setting to enjoy Ephraim's famous sunsets.

Ephraim's Fyr Bal Festival, an Ephraim tradition since 1964, is held the third week in June. The Fyr Bal Festival (Norwegian for "fire ball") is derived from the Norwegian tradition of celebrating Midsummer's Eve. Ephraim's celebration includes music, an arts fair, Norwegian dancers, and bonfires along the shore. Ephraim residents honor a member of the community as the Fyr Bal chieftain. This photograph shows the newly designated 1968 Fyr Bal chieftain, Dr. David Stevens.

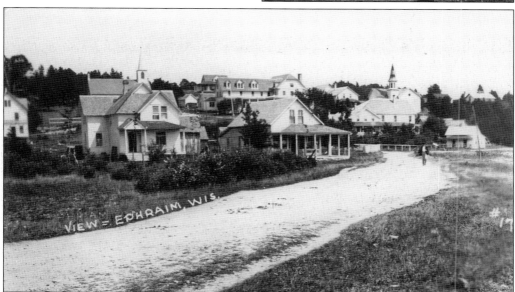

Ephraim's most enduring image shows off two white church steeples. Strolling through the present-day village, one can pick out the original shape of many early buildings, including the churches, the Smith home, the Anderson Hotel, the Hillside Hotel, and Wilson's Ice Cream Parlor. Outside the picture are the old creamery, the Clover Farm store, the Pioneer Schoolhouse, the 1853 Iverson House, and many more historic structures that have been lovingly preserved for the future.

INDEX

Across America, People are Discovering Something Wonderful. Their Heritage.

Arcadia Publishing is the leading local history publisher in the United States. With more than 3,000 titles in print and hundreds of new titles released every year, Arcadia has extensive specialized experience chronicling the history of communities and celebrating America's hidden stories, bringing to life the people, places, and events from the past. To discover the history of other communities across the nation, please visit:

www.arcadiapublishing.com

Customized search tools allow you to find regional history books about the town where you grew up, the cities where your friends and family live, the town where your parents met, or even that retirement spot you've been dreaming about.